HISTORIC MAPS AND VIEWS OF
VIENNA

HANNAH SCHWEIZER

*Historische
Karten und Ansichten
von Wien*

*Cartes et
vues historiques
de Vienne*

h.f.ullmann

Idea and series design by Black Dog and Leventhal Publishers

Cover and interior design: Prill Partners producing

Image credits:
All images © dpa Picture-Alliance GmbH, Frankfurt am Main

© 2010 for this edition: Tandem Verlag GmbH
h.f.ullmann is an imprint of Tandem Verlag GmbH

Translation to English: Cathy Lara, Sebastopol, CA
Translation to French: Laurence Wuillemin, München
Editor: Harro Schweizer, Berlin
Typesetting: Prill Partners producing, Berlin
Lithography: LVD GmbH, Berlin
Project coordination: Frederik Kugler
Overall responsibility for production: h.f.ullmann publishing, Potsdam, Germany

Printed in China

ISBN: 978-3-8331-5967-1

10 9 8 7 6 5 4 3 2 1
X IX VIII VII VI V IV III II I

If you would like to be informed about forthcoming h.f.ullmann titles, you can request our newsletter by visiting our website (**www.ullmann-publishing.com**) or by emailing us at: newsletter@ullmann-publishing.com.
h.f.ullmann, Birkenstraße 10, 14469 Potsdam, Germany

INTRODUCTION

Vienna – that reminds us of Wolfgang Amadeus Mozart and the beautiful "Sisi," legendary Empress Elisabeth; of the clattering of horse-drawn hackney cabs on the old cobblestones around St. Stephen's Cathedral and of waiters speaking the Viennese dialect serving Kaiserschmarrn and Sachertorte in their tailcoats at the venerable coffeehouses; of the proud white Lipizzaner horses of the Royal Spanish Riding School and the golden facades of the many castles and palaces. And all this is enveloped by the soft tunes of Viennese waltz ballroom music – what a cheerful and relaxed city, or so it seems.

But that was not always the case. Vienna, too, suffered from wars and battles, combats, conflicts and occupying forces, from hardships and losses. As with other major European cities, such times have left their mark on the city's face. The emergence, modification and disappearance of parts of the city, the dependency of its infrastructure on the respective political and historical situation – all of this can be retraced quite clearly with the help of city maps, because these maps are autonomous documents of their time and much more than just two-dimensional representations of streets, roads, and traffic networks.

The founding of Vienna dates back to the Romans who, in 15 BC, built a legionary fortress called Vindobona, as well as an attached encampment village for the troops and a civilian city; the Romans awarded a town charter to the city a few years later. In 881, the city of Vienna, still called Weniam at this time, is first mentioned in a document. The Magyars conquered the city in the Early Middle Ages, but after Otto the Great's (912–973) victory in Vienna in 955, a type of fortified city against the East was created under Babenberg rule. In 1278, Habsburg King Rudolf I (1218–1291) conquered the city, which marks the start of the Habsburgs' almost 650-year reign that would turn Vienna into a cultural and political center in Europe. In 1529, the Turks, under Sultan Süleyman I. (1494/96–1566), first attempted to conquer the city, though with as little success as in 1683 under Grand Vizier Kara Mustafa Pascha (1634/35–1683). But even if the Turks could not conquer the city, they left a permanent mark on Vienna and its culture: It was the Turks who brought coffee to the city and who thus founded the coffeehouse tradition. Mozart not only composed a Turkish march (Rondo Alla Turca), but also "The Abduction from the Seraglio," an opera situated in mid-16th century Turkey at Pasha Selim's country palace. And as legend has it, the Turks are to thank for the croissant, too. Shaped like a crescent, the symbol of the Turks, it was said to be created by a Viennese baker ecstatic about the victory over the Turks.

Destroyed by fighting, Vienna was rebuilt in the Baroque style, flourishing once more and rising to the position of a global metropolis. Charles VI (1685–1740) had Hofburg Castle expanded and Schönbrunn Palace constructed; he commissioned magnificent buildings for administration and culture, and the nobility and upper classes now had grand, lavish palaces and grounds established outside of Vienna. Today, there are more than 27 castles and over 150 palaces in Vienna. Under Charles VI, the Habsburg Empire attained its greatest extent, and Vienna, too, grew with the economic upturn and subsequent ten-fold increase of its population.

Of extraordinary importance in the political sense in Austrian history is Maria Theresa (1717–1780), who made Austria acquire crucial significance within its European context and who redesigned the capital city, Vienna. As such, in the mid-18th century, Vienna evolved into a theater town, and with Joseph Haydn (1732–1809), Wolfgang Amadeus Mozart (1756–1791), Bernardo Bellotto (1721/1722–1780), and Laurenz Janscha (1749–1812), music, painting, and dance also came to Vienna. Emperor Joseph II (1741–1790), who was elected Roman-German emperor in 1765, carried out educational and democratic reforms, over time creating a very novel sense of self-confidence and national pride that had never before existed in this form.

In 1814/1815, after the victory over Napoleon, the glorious Congress of Vienna restored the old political conditions and – for its magnificent and considerably extensive social life outside of negotiating rooms – went down in history under the motto "The Congress Dances, but he does not come forward". In 1848, Maria Theresa's 18-year-old son Franz Joseph I (1830–1916) ascended the throne and six years later married young "Sisi," Elisabeth Amalie Eugenie (1837–1898), whose beauty and artlessness quickly made her popular with the people. Around the turn of the century, a Viennese variant of Art Nouveau evolved that was very significant for art history, the "Vienna Secession." Due to an enormous influx of immigrants, Vienna's population reached its all-time historical high in 1910, when it had more than two million inhabitants. The end of the First World War coincided with the end of the Austrian-Hungarian monarchy, and in 1919 the Republic of Austria was proclaimed. Vienna survived the Second World War with manageable damages and was briefly divided into four sectors by the victorious powers.

Today, Vienna has 1.7 million residents who live in twenty-three districts that cover a 415-square-kilometer area.

Vienna offers its visitors a very diverse cultural life, traditional coffeehouses and delicious cuisine, as well as the unparalleled contrast between splendid Baroque buildings and the simple elegance of Viennese Art Nouveau, between the splendor of past times and the sobriety of a modern European metropolis – Vienna is different!

EINLEITUNG

Wien – das lässt an Wolfgang Amadeus Mozart denken und an die wunderschöne »Sisi«, die sagenumwobene Kaiserin Elisabeth; an die klappernden Hufe der Fiaker auf dem alten Kopfsteinpflaster rund um den Stephansdom und den Wiener Schmäh der Kellner, die in ihren Fracks in den ehrwürdigen Caféhäusern Kaiserschmarrn und Sachertorte servieren; an die stolzen weißen Lipizzanerhengste der Spanischen Hofreitschule und die gold-gelben Fassaden der zahlreichen Schlösser und Palais. Und über all dem erklingt leise die Musik des Wiener Walzers – eine heitere und gelassene Stadt, so scheint es.

Doch das war nicht immer so. Auch Wien litt unter Kriegen und Schlachten, Kämpfen, Konflikten und Besatzungen, unter Entbehrungen und Verlusten. Solche Zeiten haben, wie in anderen großen Städten Europas auch, das Gesicht der Stadt geprägt. Das Entstehen, Verändern und Verschwinden von Stadtteilen, die Abhängigkeit der Infrastruktur von der jeweiligen politischen und historischen Lage – all dies kann sehr deutlich anhand von Stadtplänen nachvollzogen werden, denn sie sind unabhängige Dokumente ihrer Zeit und weitaus mehr als nur eine zweidimensionale Darstellung von Straßen, Wegen und Verkehrsnetzen.

Die Gründung Wiens geht auf die Römer zurück, die 15 v. Chr. ein Legionslager mit dem Namen Vindobona errichteten sowie ein dazu gehöriges Lagerdorf und eine Zivilstadt, der sie einige Jahre später das Stadtrecht verliehen. Im Jahr 881 wird erstmals die Stadt Wien, damals noch unter dem Namen Weniam, urkundlich erwähnt. Nachdem im Frühmittelalter die Magyaren die Stadt erobert hatten, entstand nach dem Sieg Otto des Großen (912–973) im Jahr 955 in Wien unter Babenberger Herrschaft eine Art Wehrstadt gegen den Osten. 1278 eroberte der Habsburger König Rudolf I. (1218–1291) die Stadt; damit begann die fast 650-jährige Regentschaft der Habsburger, die Wien zu einem kulturellen und politischen Zentrum Europas machen sollten. 1529 versuchten die Türken unter Sultan Süleyman I. (1494/96–1566) erstmals, die Stadt einzunehmen, doch hatten sie genauso wenig Erfolg wie 1683 unter dem Großwesir Kara Mustafa Pascha (1634/35–1683). Doch auch wenn die Türken die Stadt nicht einnehmen konnten, beeinflussten sie Wien und die Kultur nachhaltig: Sie waren es, die den Kaffee in die Stadt brachten und damit die Caféhaus-Tradition begründeten, Mozart komponierte nicht nur einen Türkischen Marsch (Rondo Alla Turca) sondern auch »Die Entführung aus dem Serail«, eine Oper, die Mitte des 16. Jahrhunderts auf dem Landgut des Bassa Selim in der Türkei spielt. Und auch das Croissant soll zumindest der Legende nach den Türken zu verdanken sein, kreiert von einem Wiener Bäcker aus Freude über den Sieg über die Türken in Form des Halbmondes, Symbol der Türken.

Der Wiederaufbau der zerstörten Stadt im barocken Stil ließ Wien neu erblühen und zu einer Weltmetropole aufsteigen. Karl VI. (1685–1740) veranlasste nun, die Hofburg zu erweitern und Schloss Schönbrunn zu errichten, gab prächtige Gebäude für die Verwaltung und Kultur in Auftrag, und Adel sowie Großbürgertum ließen sich jetzt außerhalb von Wien großzügige und herrschaftliche Palais und Anlagen bauen. Heute finden sich in Wien über 27 Schlösser und mehr als 150 Palais. Unter Karl VI. erreichte das Habsburgerreich seine größte Ausdehnung, und auch Wien vergrößerte sich mit dem wirtschaftlichen Aufschwung und dem damit einhergehenden Zuzug um das Zehnfache.

Die politisch herausragende Figur der österreichischen Geschichte ist Maria Theresia (1717–1780), die Österreich innerhalb Europas ein bestimmendes Gewicht verlieh und die Hauptstadt Wien neu gestaltete. So entwickelte sich Wien Mitte des 18. Jahrhunderts zur Theater- und Schauspielstadt; mit Joseph Haydn (1732–1809) und Wolfgang Amadeus Mozart (1756–1791), Bernardo Bellotto (1721/1722–1780) und Laurenz Janscha (1749–1812) zogen zudem die Musik, die Malerei und der Tanz in Wien ein. Der 1765 zum römisch-deutschen Kaiser gewählte Kaiser Joseph II. (1741–1790) setzte aufklärerische und demokratische Reformen durch und schuf mit der Zeit so ein neues Selbstbewusstsein und einen Nationalstolz, den es in dieser Form zuvor nicht gab.

1814/1815 stellte der ruhmreiche Wiener Kongress nach dem Sieg über Napoléon (1769–1821) die alten politischen Verhältnisse wieder her und ging aufgrund seines glänzenden und ausgeprägten gesellschaftlichen Lebens außerhalb der Verhandlungsräume unter dem Motto »Der Kongress tanzt, aber er kommt nicht vorwärts« in die Geschichte ein. 1848 bestieg Maria Theresias 18-jähriger Sohn Franz Joseph I. (1830–1916) den Thron und heiratete sechs Jahre später die junge und aufgrund ihrer Schönheit und Natürlichkeit beim Volk rasch beliebte »Sisi« Elisabeth Amalie Eugenie (1837–1898). Um die Jahrhundertwende bildete sich eine kunstgeschichtlich sehr wertvolle Wiener Variante des Jugendstils als »Wiener Secession« heraus. Infolge eines enormen Stroms von Zuwanderern erreichte Wien 1910 mit über zwei Millionen Menschen seinen historischen Höchststand. Das Ende des Ersten Weltkriegs bedeutete zugleich das Ende der österreichisch-ungarischen Monarchie, und 1919 wurde die Republik Österreich ausgerufen. Den Zweiten Weltkrieg überstand die Stadt Wien, kurzzeitig in vier Sektoren der Siegermächte aufgeteilt, mit überschaubaren Schäden.

Heute zählt Wien rund 1,7 Millionen Einwohner, die in dreiundzwanzig Bezirken auf einer Fläche von rund 415 Quadratkilometern leben.

Wien bietet seinen Besuchern ein überaus vielfältiges Kulturleben, traditionelle Caféhäuser und eine gaumenfreudige Küche sowie den unvergleichlichen Kontrast von barocken Prachtbauten und der schlichten Eleganz des Wiener Jugendstils, vom Glanz vergangener Zeiten und der Nüchternheit einer modernen europäischen Metropole – Wien ist anders!

INTRODUCTION

Vienne – une ville qui évoque à la fois Wolfgang Amadeus Mozart et la merveilleuse « Sisi », la légendaire impératrice Élisabeth, le martèlement des sabots des chevaux attelés aux fiacres sur les vieux pavés autour de la cathédrale Saint-Étienne et l'humour viennois des garçons en frac servant du Kaiserschmarrn et de la Sachertorte dans les honorables cafés, les fiers lipizzans blancs de l'École espagnole d'équitation et les façades d'un blond doré des nombreux châteaux et palais. Et, résonnant doucement au-dessus de tout cela, la musique des valses viennoises – une ville enjouée et sereine, semblerait-il.

Mais il n'en fut pas toujours ainsi. Vienne a elle aussi souffert des guerres et des batailles, des combats et des conflits, des occupations, des privations et des pertes. Ces époques ont marqué la physionomie de la ville, tout comme celle des autres métropoles européennes. La création de quartiers, leur modification et leur disparition, l'influence de la situation politique et historique sur l'infrastructure, tout ceci peut être suivi attentivement grâce aux plans de la ville, car, bien plus qu'une simple représentation bidimensionnelle de rues, de chemins et de réseaux de communication, ce sont des documents autonomes de leur époque.

La fondation de Vienne remonte aux Romains qui, en 15 av. J.-C., avaient établi une légion du nom de Vindobona, ainsi qu'un village attenant et une ville civile, à laquelle ils octroyèrent quelques années plus tard le droit de municipe. En 881, la ville de Vienne est évoquée pour la première fois dans des documents, jadis encore sous le nom de Weniam. Après la conquête de la ville par les Magyars, qu'Otto Ier (912–973) vaincra en 955, un genre de ville fortifiée contre l'Est verra le jour à Vienne sous le règne des Babenberg. En 1278, le roi Rodolphe Ier de Habsbourg (1218–1291) va s'emparer de la ville ; c'est ainsi que débutera le règne des Habsbourgs, qui durera presque 650 ans, et fera de Vienne un centre culturel et politique de l'Europe. En 1529, les Turcs, menés par Soliman I (1494/96–1566) tenteront pour la première fois d'occuper la ville, sans plus de succès qu'en 1683 sous le grand vizir Kara Mustafa Pacha (1634/35–1683). Néanmoins, même si les Turcs ne réussirent pas à prendre la ville, ils l'ont influencée, ainsi que sa culture, de manière durable : c'est à eux que l'on doit d'avoir introduit le café dans la ville, fondant ainsi la tradition des célèbres cafés viennois, et Mozart ne composa pas seulement une marche turque (Rondo Alla Turca), mais aussi « L'enlèvement au sérail », un singspiel qui se déroule au milieu du XVIe siècle dans le domaine de Bassa Selim, en Turquie. Et c'est également à eux que le croissant devrait être dû, au moins selon la légende, puisqu'un boulanger viennois l'aurait créé d'après la forme de la lune, ce symbole ottoman, pour manifester sa joie à l'occasion de la victoire sur les Turcs.

La reconstruction en style baroque de la ville détruite la fera refleurir et accéder au rang de métropole mondiale. Charles VI du Saint-Empire (1685–1740) fera à présent agrandir le château du Hofburg et ériger celui de Schönbrunn, ordonnera la construction de magnifiques bâtiments destinés à l'administration et aux activités culturelles, et la noblesse et la haute bourgeoisie se feront dorénavant bâtir de vastes palais et édifices seigneuriaux à la périphérie de Vienne. Aujourd'hui, plus de 27 châteaux et de 150 palais se trouvent encore à Vienne. Sous Charles VI, l'empire des Habsbourgs atteindra sa plus grande expansion, et Vienne elle-même s'agrandira grâce à l'essor économique allant de pair avec l'afflux d'une population qui décuplera.

Le personnage politique remarquable de l'histoire du pays est Marie-Thérèse (1717–1780), qui conférera à l'Autriche un poids particulier au sein de l'Europe et réaménagera la capitale. C'est ainsi que Vienne, au milieu du XVIIIe siècle, deviendra une ville de théâtre et de spectacles ; en outre, la musique avec Joseph Haydn (1732–1809) et Wolfgang Amadeus Mozart (1756–1791), la peinture avec Bernardo Bellotto (1721/1722–1780) et la danse avec Laurenz Janscha (1749–1812) feront leur entrée à Vienne. Élu empereur du Saint-Empire germanique en 1765, Joseph II, (1741–1790), imposera des réformes modernes et démocratiques et créera ainsi avec le temps, une nouvelle assurance et une fierté nationale qui n'existaient pas sous cette forme auparavant.

Le célèbre congrès de Vienne de 1814/1815 rétablira les anciens rapports politiques après la victoire sur Napoléon (1769–1821) et entrera dans l'Histoire sous le mot fameux : « Le congrès ne marche pas, il danse » en raison des festivités qui se déroulaient parallèlement aux négociations. En 1848, le fils de Marie-Thérèse, François-Joseph (1830–1916), âgé de 18 ans, montera sur le trône et épousera six ans plus tard la jeune Élisabeth Amélie Eugénie, dite « Sisi », (1837–1898), dont le peuple s'entichera rapidement en raison de sa beauté et de son naturel. Au tournant du siècle se cristallisera une variante viennoise du Jugendstil très précieuse en histoire de l'art, la « Sécession viennoise ». À la suite d'un flux énorme de migrants, Vienne atteindra en 1910, avec plus de deux millions de personnes, son niveau maximum historique. La fin de la Première Guerre mondiale sera aussi synonyme de la fin de la monarchie austro-hongroise, et en 1919 sera proclamée la République d'Autriche. La ville de Vienne sortira de la Seconde Guerre mondiale, temporairement divisée en quatre secteurs par les puissances alliées, avec des dommages surmontables.

Aujourd'hui, Vienne compte 1,7 millions d'habitants, vivant dans vingt-trois districts sur une superficie de 415 kilomètres carrés.

Vienne offre à ses visiteurs une vie culturelle des plus variées, des cafés traditionnels et une cuisine de gourmets, ainsi que l'incomparable contraste entre de superbes édifices baroques et la sobre élégance du Jugendstil viennois, entre l'éclat des temps révolus et le prosaïsme d'une métropole européenne moderne : Vienne est différente !

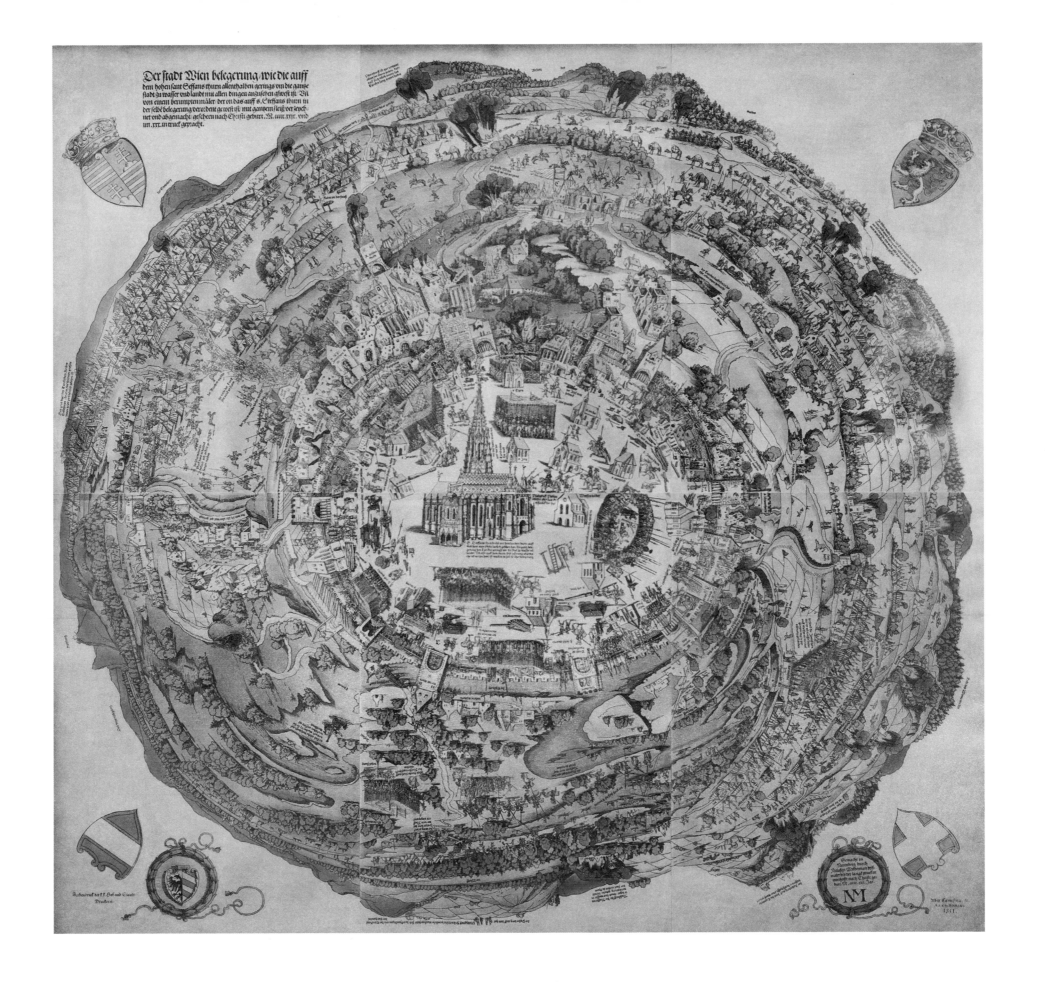

Panoramic View of the City of Vienna at the Time of the First Turkish Siege 1529

Chromolithograph by Albert Camesina, 1851, after a colored woodcut from 1529, consisting of six sheets of paper

The map shows Vienna facing the onslaught of Turkish troops under the command of Sultan Süleyman I (1494/95/96–1566). In the city's center is St. Stephen's Cathedral, which during the siege from September to October 1529 was used as an observation post; visible above it is the Carinthian Gate. The Turks seem to be tearing holes in the city walls; a big fire has broken out next to the gate; to the left, wooden slats have already been used to repair the holes. Defenders on horseback and foot have positioned themselves in formation around St. Stephen's Cathedral, setting up canons and other defensive devices. Commissioned by German publisher and printer Niklas Meldemann (d. 1530), this imposing panorama of Vienna was presumably made by Hans Sebald Beham (1500–1550), a student of Albrecht Dürer's. Meldemann published this remarkably detailed view in book form in 1530, one year after it was made.

Rundansicht der Stadt Wien zur Zeit der Ersten Türkenbelagerung 1529

Farblithographie von Albert Camesina, 1851, nach einem kolorierten Holzschnitt von 1529, bestehend aus sechs Blättern

Der Plan zeigt Wien mit den anstürmenden türkischen Truppen unter dem Kommando von Sultan Süleyman I. (1494/95/96–1566). Im Zentrum der Stadt steht der Stephansdom, der zur Zeit der Belagerung von September bis Oktober 1529 als Beobachtungsposten genutzt wurde, darüber ist das Kärntner Tor zu erkennen. Die Türken schlagen offenbar Breschen in die Stadtmauern; rechts neben dem Tor ist ein starkes Feuer ausgebrochen, links sind die Breschen bereits mit Holzlatten ausgebessert worden. Um den Stephansdom haben sich Formationen von Verteidigern zu Pferd und zu Fuß versammelt und Kanonen sowie anderes Abwehrgerät bereitgestellt. Beauftragt vom deutschen Verleger und Drucker Niklas Meldemann (gest. 1530), stellte diese imposante Gesamtansicht Wiens vermutlich Hans Sebald Beham (1500–1550) her, ein Schüler Albrecht Dürers. Meldemann gab diese außergewöhnlich detaillierte Ansicht 1530, einem Jahr nach der Entstehung, in Buchform heraus.

Vue circulaire de la ville de Vienne au moment du premier siège par les Turcs en 1529

Lithographie en couleur d'Albert Camesina, 1851, d'après une gravure sur bois coloriée de 1529, comportant six feuilles

Le plan montre Vienne sous l'assaut des troupes ottomanes, commandées par le sultan Soliman I (1494/95/96-1566). Au centre de la ville se trouve la cathédrale Saint-Étienne, qui servit de poste d'observation durant le siège de septembre à octobre 1529, au-delà, on reconnaît la porte de Carinthie. Les Turcs sont visiblement en train d'ouvrir des brèches dans les remparts de la ville ; à droite de la porte, un incendie s'est déclaré, à gauche, les brèches ont déjà été colmatées par des planches. Autour de la cathédrale se sont rassemblées des formations de défenseurs à cheval et à pied, les canons et autres armes défensives sont déjà prêts. Commandée par l'éditeur et imprimeur allemand Niklas Meldemann (mort en 1530), cette imposante vue d'ensemble de Vienne a probablement été réalisée par Hans Sebald Beham (1500–1550), un élève d'Albrecht Dürer. Meldemann publia cette particulièrement détaillée en 1530 sous forme de livre, un an après sa réalisation.

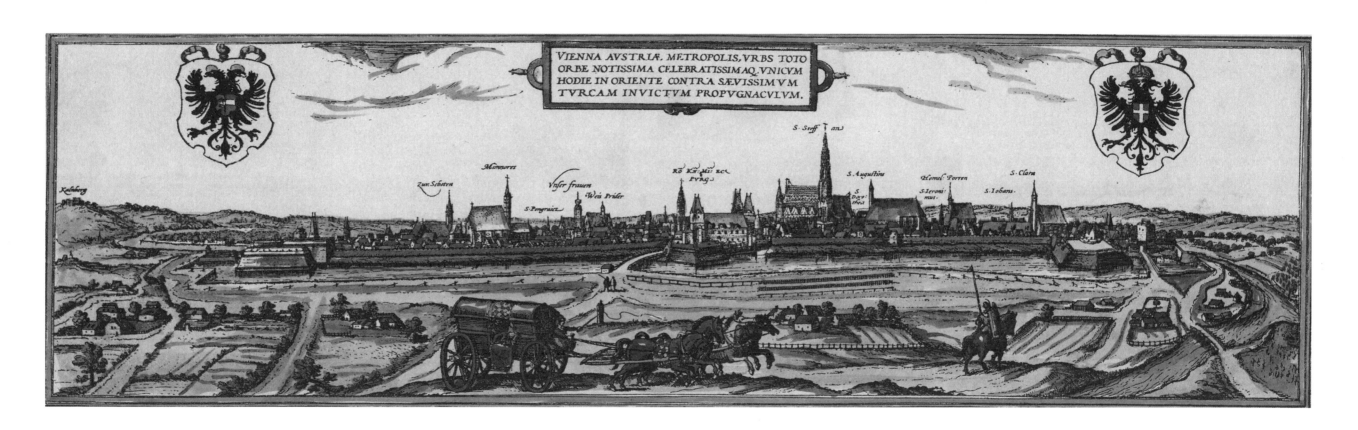

VIENNA AVSTRIÆ METROPOLIS, VRBS TOTO
ORBE NOTISSIMA CELEBRATISSIMAQ, VNICVM
HODIE IN ORIENTE CONTRA SÆVISSIMVM
TVRCAM INVICTVM PROPVGNACVLVM.

Vienna Austriae Metropolis

Copper engraving, later coloring from
G. Braun and F. Hogenberg, from:
Civitates Orbis Terrarum, Cologne 1572

This copper engraving shows Vienna after the reconstruction of its medieval wall in 1548 and with the main road leading into town; a horse-drawn carriage and a knight in full armor populate the foreground. St. Stephen's Cathedral dominates the city's skyline; to its right is the Augustinian Church as well as the Augustinian Monastery of St. Dorothea, which no longer exists today. On the left edge of the picture rises Mount Kahlenberg, which more than one hundred years later would play a decisive role in the second Turkish siege.

The book *Civitates Orbis Terrarum*, published by Frans Hogenberg and Georg Braun in 1572, contains over six hundred realistic views and maps of cities in Europe, Africa, Asia, and America; it is an invaluable witness of the time.

Vienna Austriae Metropolis

Kupferstich, spätere Kolorierung von
G. Braun und F. Hogenberg, aus:
Civitates Orbis Terrarum, Köln 1572

Dieser Kupferstich zeigt Wien nach dem Umbau der mittelalterlichen Stadtmauer 1548 mit der Hauptstraße zur Stadt, im Vordergrund mit Pferdekutsche und Ritter in voller Bewehrung. Der Stephansdom bestimmt die Stadtsilhouette, rechts davon die Augustinerkirche sowie das Augustiner-Chorherrenstift St. Dorothea, das heute nicht mehr existiert. Am linken Bildrand erhebt sich der Kahlenberg, der im Rahmen der zweiten Türkenbelagerung über hundert Jahre später eine entscheidende Rolle spielen sollte.

Das 1572 von Frans Hogenberg und Georg Braun herausgegebene Buch *Civitates Orbis Terrarum* beinhaltet über sechshundert wirklichkeitsnahe Ansichten und Pläne von Städten aus Europa, Afrika, Asien und Amerika und ist als Zeitzeugnis von unschätzbarem Wert.

Vienna Austriae Metropolis

Gravure sur cuivre, coloriée ultérieurement
par G. Braun et F. Hogenberg, tirée de :
Civitates Orbis Terrarum, Cologne 1572

Cette gravure sur cuivre montre Vienne après les travaux effectués sur le rempart médiéval en 1548, avec la route principale menant à la ville, au premier plan avec carrosse et cavalier en armure. La cathédrale Saint-Étienne domine la silhouette de la ville, à sa droite se trouve l'église des Augustins et le collège de chanoines augustins Sainte-Dorothée, qui n'existe plus aujourd'hui. Sur le bord gauche de la gravure s'élève la colline de Kahlenberg, qui devait jouer un rôle décisif dans le deuxième siège de Vienne, un bon siècle plus tard.

L'ouvrage *Civitates Orbis Terrarum*, publié en 1572 par Frans Hogenberg et Georg Braun, comprend plus de six cents vues et plans fidèles de villes en Europe, Afrique, Asie et Amérique, et c'est un témoignage contemporain d'une valeur incommensurable.

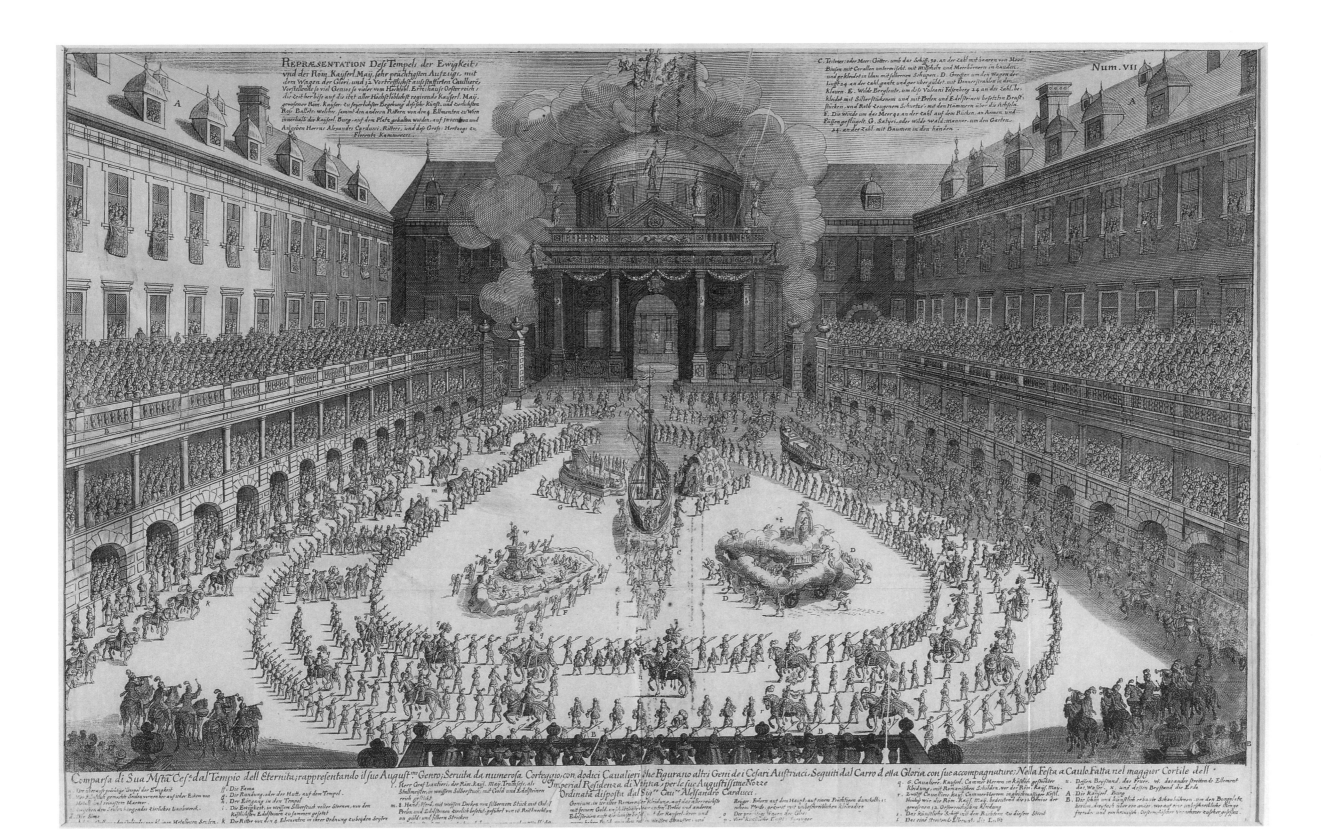

Horse Ballet in the Courtyard of Vienna Castle

Copper engraving by Jan Ossenbeeck after Nicolaus van Hay, from: G. Gualdo Priorato, *Historia di Leopoldo Cesare*, 1674

After its foundation stone was laid in 1275 under King Premysl Ottokar II (circa 1232–1278), Hofburg Castle had many rulers and underwent numerous renovations and extensions. It was always an imperial residence and today is the official residence of the Austrian president. This so-called "city within the city," covers 240,000 square meters and has 18 wings, 19 courtyards, and more than 2,600 rooms. The oldest part of the castle also contains the Stallburg, built in the 16th century. Originally designed as a residential structure, it later housed the stables. Today, it is home to the Royal Spanish Riding School.

The horse ballet shown here was staged on January 24, 1667, in the castle's courtyard in honor of the marriage of Emperor Leopold I (1640–1705) to his niece Margarita Teresa of Spain (1651–1673). More than 1,000 horsemen – including the emperor – performed this ballet for over four hours; it was supposed to demonstrate the animals' elegance and their riders' dressage skills and was presented as a spectacle entitled "Temple of Eternity." Visible in the background is the Amalia Wing, where Empress Elisabeth had her living quarters.

Rossballett im Innenhof der Wiener Burg

Kupferstich von Jan Ossenbeeck nach Nicolaus van Hay, aus: G. Gualdo Priorato, *Historia di Leopoldo Cesare*, 1674

Die Hofburg hat ab der Grundsteinlegung 1275 unter König Ottokar II. Premysl (um 1232–1278) viele Herrscher erlebt und zahlreiche Umgestaltungen und Erweiterungen erfahren. Sie war stets kaiserliche Residenz und ist heute der Amtssitz des österreichischen Bundespräsidenten. Diese so genannte »Stadt in der Stadt« erstreckt sich über 240 000 Quadratmeter und besteht aus 18 Trakten mit 19 Höfen und über 2600 Räumen. Im ältesten Teil der Burg befindet sich auch die im 16. Jahrhundert erbaute Stallburg. Ursprünglich als Wohnhaus gebaut, beherbergte sie später die Stallungen. Heute befindet sich dort die Spanische Hofreitschule.

Das hier dargestellte Rossballett fand zu Ehren der Hochzeit Kaiser Leopolds I. (1640–1705) mit seiner Nichte Margarita Teresa von Spanien (1651–1673) am 24. Januar 1667 im inneren Burghof statt. Über 1000 Reiter – der Kaiser eingeschlossen – zelebrierten mehr als vier Stunden lang dieses Ballett, das die Eleganz der Tiere und die Dressurkünste ihrer Reiter demonstrieren sollte und als Schauspiel angelegt war, das den Namen »Tempel der Ewigkeit« erhielt. Im Hintergrund ist der Amalientrakt zu sehen, in dem Kaiserin Elisabeth ihre Wohnräume hatte.

Ballet hippique dans la cour intérieure du château « Wiener Burg »

Gravure sur cuivre de Jan Ossenbeeck d'après Nicolaus van Hay, tirée de : G. Gualdo Priorato, *Historia di Leopoldo Cesare*, 1674

Depuis la pose de la première pierre en 1275 sous le roi Premysl Ottokar II de Bohême (vers 1232–1278), le Hofburg a vu passer de nombreux souverains et subi de multiples aménagements et agrandissements. Ce fut sans interruption une résidence impériale et c'est aujourd'hui la résidence officielle du président autrichien. Ce que l'on nomme une « ville dans la ville » s'étend sur plus de 240 000 mètres carrés et comporte 18 ailes avec 19 cours et plus de 2600 pièces. Dans la plus ancienne partie du château se trouve également le Stallburg, construit à l'origine au XVIe siècle comme habitation et qui abritera plus tard les écuries. Aujourd'hui s'y trouve l'École espagnole d'équitation.

Le ballet hippique représenté ici eut lieu le 24 janvier 1667 en l'honneur du mariage de l'empereur Léopold Ier (1640–1705) avec sa nièce Marguerite-Thérèse, infante d'Espagne (1651–1673), dans la cour intérieure du château. Plus de 1000 cavaliers, l'empereur inclus, célébrèrent pendant quatre heures ce ballet, qui devait démontrer l'élégance des montures et l'art du dressage de leurs cavaliers. Il était conçu comme un spectacle qui reçut le nom de « Temple de l'Éternité ». À l'arrière-plan, on voit l'aile Amélie, dans laquelle l'impératrice Élisabeth possédera ses appartements.

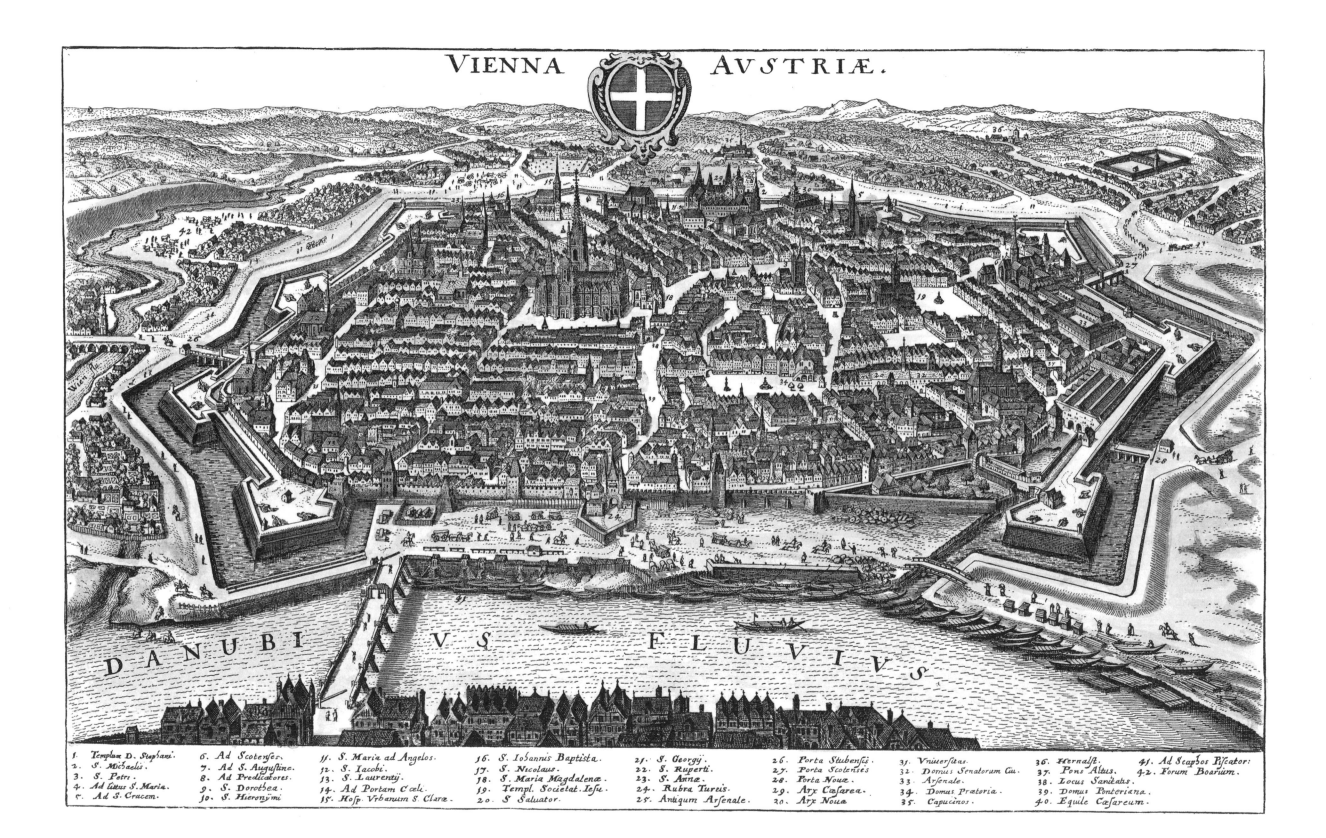

VIENNA AVSTRIÆ.

DANVBIVS FLVVIVS

Vienna Austriae – A Bird's-Eye View of the City of Vienna

Copper engraving by Matthäus Merian, the Elder, later coloring, from: *Topographia Provinciarum Austriacarum Austriae*, circa 1649

This copper engraving shows the city as it was around 1649, looking southward. Visible at the bottom are "Fischerzillen," typical fishermens' barges floating on the Danube – small, nimble boats equipped with nets and traditionally used for fishing in the Danube region; also visible is the Red Tower Gate, an entrance to the city. Parts of the old city wall are visible to the right and left of this gate. Merian numbered the prominent buildings 1 through 42, starting with St. Stephen's Cathedral (1) in the heart of the city and ending with Forum Boarium (42), located in the upper left, just outside the city gates; in Ancient Rome, this marketplace was used mainly to trade livestock. This panorama preserves some Viennese landmarks that have meanwhile vanished. For example, across from the western facade of St. Stephen's Cathedral – that is, on the right-hand side of the picture – there is the "Heiltumsstuhl," an archway with many windows where, on church holidays, relics were presented to the crowds of people attending. It was torn down in 1700.

Vienna Austriae – Vogelschauplan der Stadt Wien

Kupferstich von Matthäus Merian dem Älteren, spätere Kolorierung, aus: *Topographia Provinciarum Austriacarum Austriae*, um 1649

Der Kupferstich zeigt die Stadt um 1649 mit dem Blick gen Süden. So sind auf der Donau die so genannten Fischerzillen zu erkennen, kleine, wendige Boote zum Netzfischen, die traditionsgemäß im Donauraum eingesetzt wurden, sowie das Rotenturmtor als Eingang zur Stadt. Rechts und links von diesem Tor ist noch ein Teil der alten Stadtmauer zu erkennen.
Merian hat hier die herausragenden Bauten mit Zahlen von 1 bis 42 markiert, unter anderem den Stephansdom (1) im Zentrum der Stadt und das Forum Boarium (42) links oben vor den Stadttoren, ein Marktplatz, der im Alten Rom vorrangig zum Viehhandel genutzt wurde. Auf dieser Gesamtansicht sind einige mittlerweile verschwundene Wahrzeichen Wiens festgehalten. So befindet sich zum Beispiel gegenüber der Westfassade des Stephansdoms der »Heiltumsstuhl«, ein Torbogen mit zahlreichen Fenstern, von denen aus zu kirchlichen Feiertagen den versammelten Menschen Reliquien präsentiert wurden. Er wurde 1700 abgerissen.

Vienna Austriae – plan à vue d'oiseau de la ville de Vienne

Gravure sur cuivre de Matthäus Merian l'Ancien, coloriée ultérieurement, tirée de : *Topographia Provinciarum Austriacarum Austriae*, vers 1649

La gravure sur cuivre montre la ville vers 1649, avec vue sur le sud. On reconnaît en bas, sur le fleuve, les petites embarcations maniables nommées « Fischerzillen », traditionnelles de la pêche au filet sur le Danube, ainsi que la porte de la Tour rouge par laquelle on accédait à la ville, flanquée à droite et à gauche d'un pan du rempart médiéval. Merian a numéroté les édifices remarquables de 1 à 42, parmi lesquels la cathédrale Saint-Étienne (1) au centre de la ville, et le Forum Boarium (42) en haut à gauche devant les portes de la ville, une place de marché qui, dans la Rome antique, était avant tout destinée au commerce des bestiaux. Sur cette vue d'ensemble, quelques emblèmes de Vienne, disparus entre-temps, ont été pérennisés. Par exemple, de l'autre côté de la façade ouest de la cathédrale Saint-Étienne, se trouve le « Heiltumsstuhl » à droite sur la gravure, une porte voûtée aux multiples fenêtres, à partir desquelles des reliques étaient présentées à la foule rassemblée le jour des fêtes religieuses. Il a été démoli en 1700.

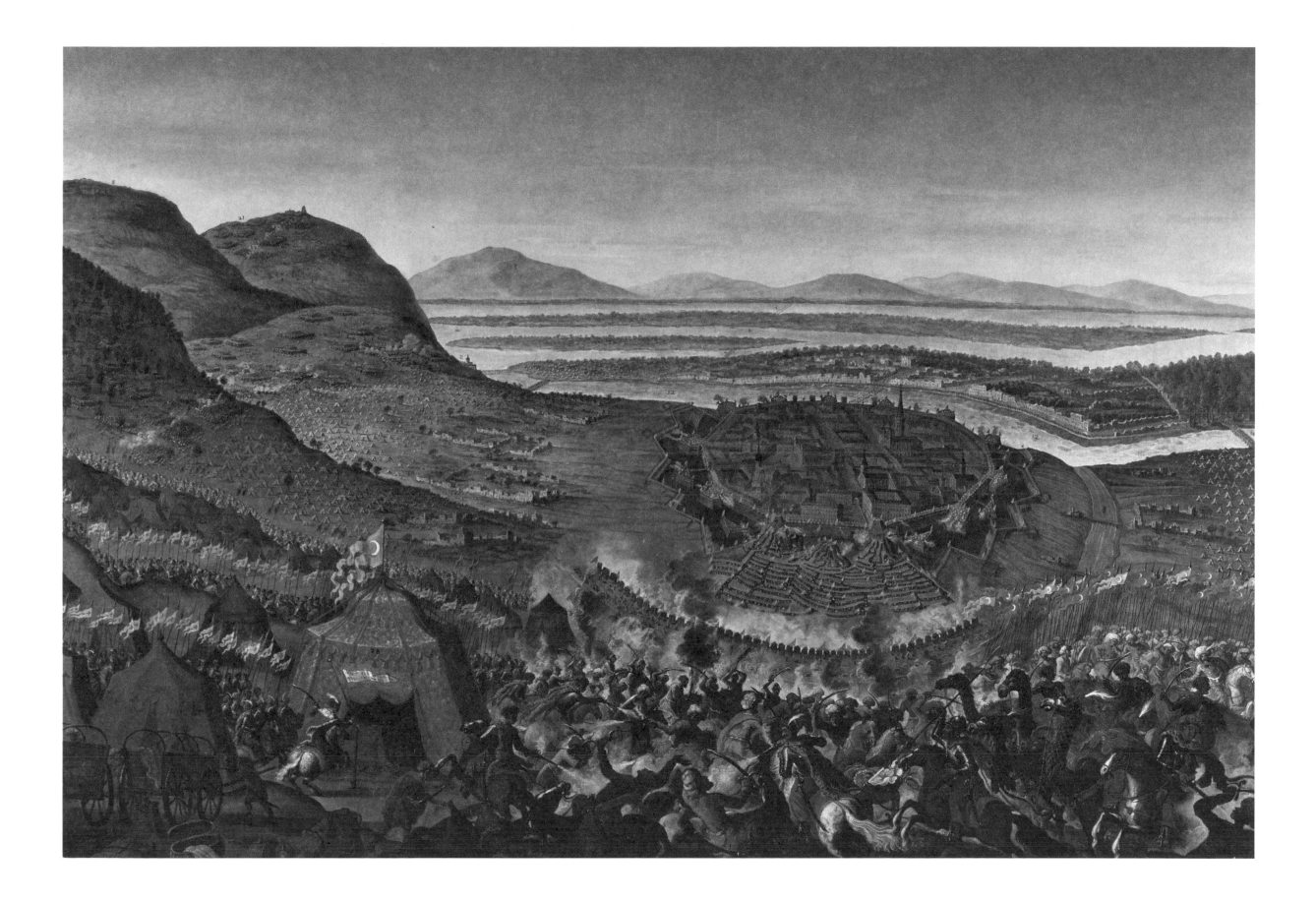

The Battle of Vienna

Oil on canvas by Franz Geffels, circa 1688

The battle at Kahlenberg on September 12, 1683, was the military highpoint in the conflict between the Ottoman Empire and the Christian Occident.

Turkish Commander Kara Mustafa Pascha (1634/35–1683) had laid siege to Vienna with his soldiers by building a tent city. To liberate Vienna, Polish King John III Sobieski (1629–1696) came to the aid of the Austrians by launching a relief attack against the Turkish troops even though their army was three times as strong. Without expecting anything and utterly surprised, the Turks were pounced on by Sobieski's men who came from Mount Kahlenberg, and within a single day, the Turkish occupation of Vienna was history. This victory marked the first step in the gradual overthrow of Ottoman power in Europe.

So as to make it easier on those looking at the picture, Geffen gave numbers to geographical and war-related objects, such as to Kara Mustafa's tent (28), shown just as Sobieski is about to take it by storm. Numbers 16 through 20 designate the trenches and mines outside the gates of Vienna that were used by the Janissaries, a unit of Turkish elite soldiers. The painter provided a legend for the numbers by adding a list.

Die Entsatzschlacht vor Wien

Öl auf Leinwand von Franz Geffels, um 1688

Die Schlacht am Kahlenberg am 12. September 1683 war der militärische Höhepunkt des Konflikts des Osmanischen Reiches mit dem christlichen Abendland.

Der türkische Feldherr Kara Mustafa Pascha (1634/35–1683) hatte mit seinen Soldaten Wien belagert, indem er eine Zeltstadt hatte aufbauen lassen. Der den Österreichern zu Hilfe kommende polnische König Johann III. Sobieski (1629–1696) begann einen Entsatzangriff gegen die dreimal stärkeren türkischen Truppen, um Wien zu befreien. Völlig unerwartet und überraschend für die Türken stürzten sich die Männer Sobieskis vom Kahlenberg aus auf die Belagerer, und innerhalb eines Tages war die türkische Belagerung Wiens Geschichte. Durch diesen Sieg wurde die schrittweise Zurückdrängung des osmanischen Machtbereichs in Europa eingeleitet.

Zum besseren Verständnis für den Betrachter nummerierte Geffels geographische und kriegsrelevante Objekte, so das Zelt des Kara Mustafa (28), wie es gerade von Sobieski erstürmt wird. Mit den Nummer 16 bis 20 sind die Laufgräben und Minen der Janitscharen, der türkischen Eliteeinheit, vor den Mauern Wiens gekennzeichnet. Die Ziffern entschlüsselte der Maler anhand einer beigefügten Liste.

La contre-attaque devant Vienne

Huile sur toile de Franz Geffels, vers 1688

La bataille de Vienne près du Kahlenberg le 12 septembre 1683 fut l'apogée militaire du conflit entre l'Empire ottoman et l'Occident chrétien.

Le commandant en chef turc, Kara Mustafa Pacha (1634/35–1683), avait fait le siège de Vienne avec ses soldats en faisant établir un campement autour de Vienne. Le roi polonais, Jean III Sobieski (1629–1696), arrivant à la rescousse des Autrichiens, lança une contre-attaque contre les troupes trois fois plus nombreuses des Turcs afin de libérer Vienne de son encerclement. Totalement par surprise, les hommes de Sobieski chargèrent les assiégeants depuis la colline du Kahlenberg et en l'espace d'une journée, le siège de Vienne par les Turcs fit partie de l'histoire ancienne. Cette victoire sonna le recul progressif du pouvoir ottoman en Europe.

Afin de faciliter la compréhension du spectateur, Geffels numérota soit des objets géographiques ou ayant trait à la guerre, comme la tente de Kara Mustafa (28), que Sobieski est en train d'attaquer. Les numéros 16 à 20 signalent les sapes et les mines de janissaires, les unités d'élite turques, devant les murs d'enceintes de la ville. Grâce à une liste jointe, le peintre donne la correspondance des numéros.

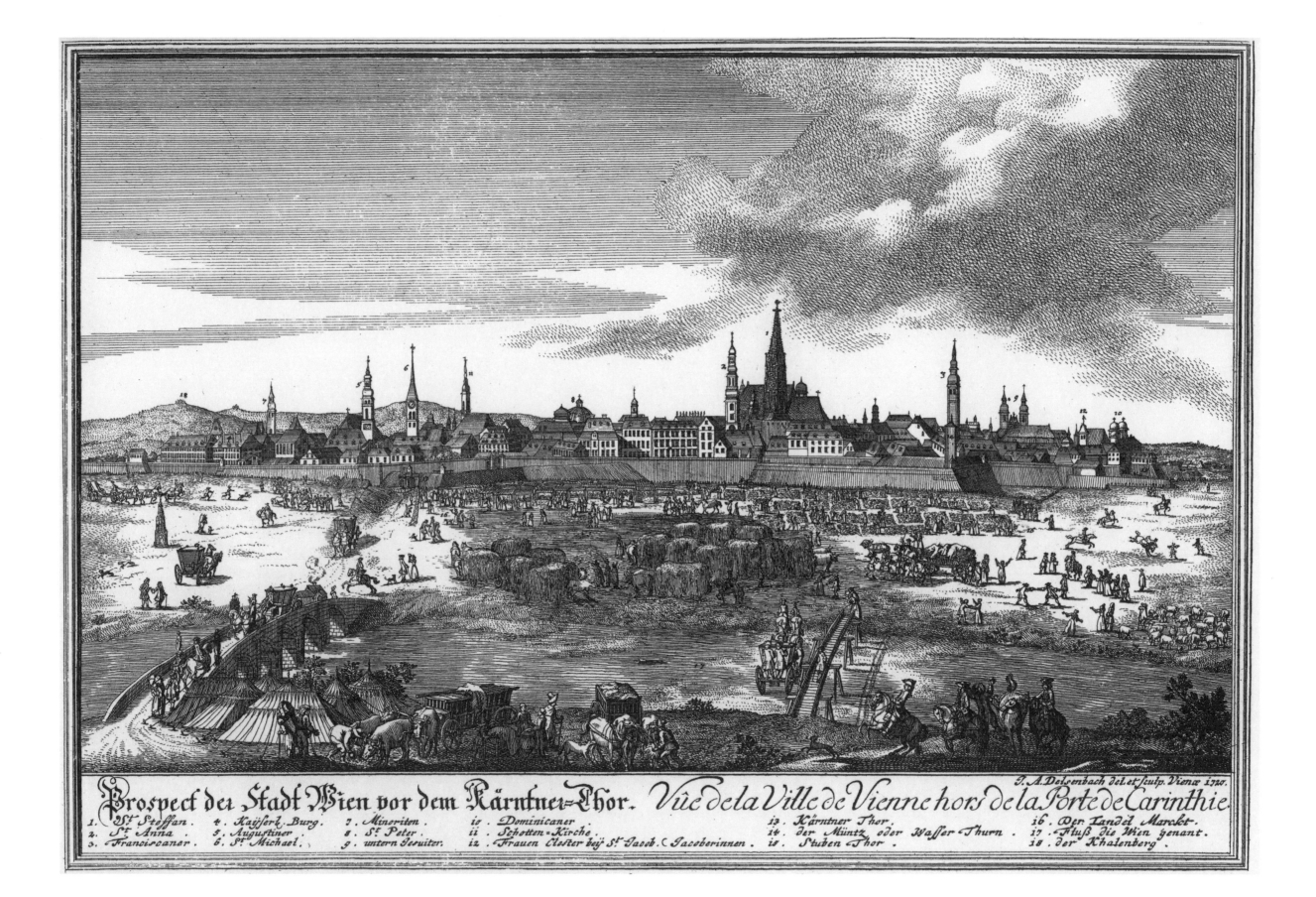

J.A.Delsenbach del.et sculp. Viennæ 1720.

Prospect der Stadt Wien vor dem Kärntner-Thor. Vüe de la Ville de Vienne hors de la Porte de Carinthie.

1. St. Steffan.
2. St. Anna.
3. Franciscaner.
4. Kaÿserl. Burg.
5. Augustiner.
6. St. Michael.
7. Minoriten.
8. St. Peter.
9. untern Jesuiter.
10. Dominicaner.
11. Schotten-Kirche.
12. Frauen Closter beÿ St. Jacob. (Jacoberinnen).
13. Kärntner Thor.
14. der Müntz oder Wasser Thurn.
15. Stuben Thor.
16. Der Landel Marckt.
17. Fluß die Wien genant.
18. der Khalenberg.

View of Vienna from a Position Outside the Carinthian Gate

Copper engraving by Johann Adam Delsenbach, 1720

This is a view of Vienna as seen from the south, looking toward the old Carinthian Gate; the most important buildings and sites, chiefly churches, are numbered. We can see that there used to be a lot of lively agricultural activity outside the gates of Vienna, with flocks of sheep and fields of farming. The introduction of new crops such as clover, rape, and potatoes, as well as of new agricultural technology, including moldboard plows and horseshoes, meant that revenues could be increased and that farmers could improve their finances and social standing.

Despite epidemics and catastrophic fires, Vienna's population constantly increased. In 1700, with more than 100,000 residents, Vienna was the sixth largest city in Europe. The first official census, however, was not conducted until 1754 under Maria Theresa, and this one already counted 175,000 residents.

Prospect der Stadt Wien vor dem Kärntner-Thor

Kupferstich von Johann Adam Delsenbach, 1720

Eine Ansicht der Stadt Wien vom Süden her mit Blick auf das alte Kärntertor. Die wichtigsten Orte und Bauten, zum größten Teil Kirchen, sind nummeriert. Zu sehen ist ein reges landwirtschaftliches Treiben mit Schafsherden und Ackerbau vor den Toren Wiens. Durch die Einführung neuer Feldfrüchte wie Klee, Raps und Kartoffeln sowie neuer landwirtschaftlicher Techniken wie zum Beispiel dem Bodenwendepflug oder der systematischen Behufung von Pferden konnten die Erträge gesteigert werden und die Bauern zu Geld und Ansehen gelangen.

Trotz einiger Seuchen und Brandkatastrophen stieg die Einwohnerzahl Wiens stetig. Um 1700 galt Wien mit seinen über 100 000 Einwohnern als sechstgrößte Stadt Europas. Die erste offizielle Volkszählung fand allerdings erst 1754 unter Maria Theresia statt und ermittelte bereits 175 000 Einwohner.

Vue de la ville de Vienne hors la porte de Carinthie

Gravure sur cuivre de Johann Adam Delsenbach, 1720

Une vue de la ville de Vienne depuis le sud sur l'ancienne porte de Carinthie ; les principaux édifices et endroits, en majeure partie des églises, sont numérotés. On reconnaît une dynamique activité agricole avec des troupeaux de moutons et des champs cultivés aux portes de la ville. Grâce à l'introduction de nouvelles cultures comme le trèfle, le colza et la pomme de terre, et de nouvelles techniques agricoles comme, par exemple, la charrue à versoir ou le ferrage systématique des chevaux, les récoltes purent être améliorées, et les paysans augmenter leurs gains et gagner en considération.

Malgré quelques épidémies et des incendies, le nombre des habitants de Vienne s'éleva continuellement. Vers 1700, la ville, qui dépassait les 100 000 habitants, faisait partie des six plus grandes villes européennes. Le premier recensement de la population n'eut toutefois lieu qu'en 1754 sous le règne de Marie-Thérèse et dénombrait déjà 175 000 habitants.

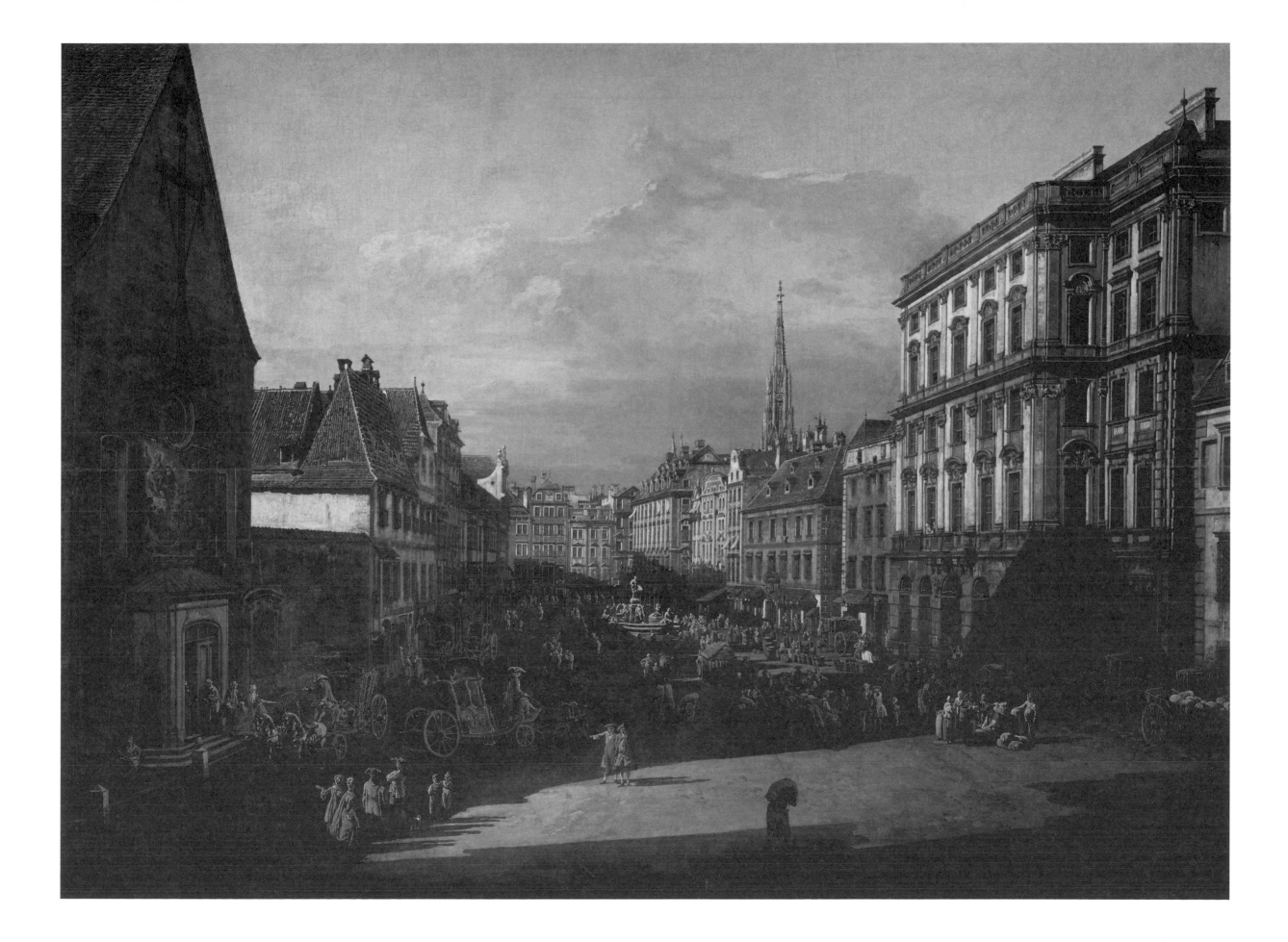

The Flour Market in Vienna

Oil on canvas by Bernardo Bellotto, circa 1758/61

The New Market is located in the heart of Vienna's Old Town and since 1234 has been known by the name "Novum Forum" or "Flour Market." The latter name dates back to the time when the New Market was a trading center for grain, flour, and legumes, and a granary stood here, the so-called Mehlgrube, which can be seen in the picture's left. When the new Schanzl trading center near Salztor Bridge on the Danube Canal's right bank made grain trading at the New Market obsolete, the square nevertheless retained its old name, Flour Market, even though its signature items were replaced by a market for ordinary groceries. The Mehlgrube granary was then remodeled into a ballroom and concert hall featuring young artists like Joseph Haydn, Mozart as well as, later, Ludwig van Beethoven.

But most striking on the New Market was the Providentia Fountain, completed in 1739 by Raphael Georg Donner (1693–1742) and decorated with four prominent figures symbolizing major Austrian rivers.

Der Mehlmarkt in Wien

Öl auf Leinwand von Bernardo Bellotto, um 1758/61

Der.Neue Markt liegt mitten in der Altstadt Wiens und ist seit 1234 unter dem Namen »Novum Forum« oder auch »Mehlmarkt« bekannt. Letztere Bezeichnung stammt aus der Zeit, als der Neue Markt Handelsplatz für Getreide, Mehl und Hülsenfrüchte war und hier ein Speicher stand, die so genannte Mehlgrube, im Bild links zu sehen. Als der Getreidehandel am Neuen Markt aufgrund des neuen Umschlagplatzes am Schanzl bei der Salztorbrücke am rechten Donaukanalufer bedeutungslos wurde, behielt der Platz dennoch den Namen Mehlmarkt, nur siedelte sich hier jetzt ein gewöhnlicher Lebensmittelmarkt an. Die Mehlgrube wurde umgebaut und war nun Ball- und Konzertsaal, in dem junge Künstler wie Joseph Haydn, Mozart und später auch Ludwig van Beethoven auftraten.

Blickfang auf dem Neuen Markt ist allerdings der 1739 von Raphael Georg Donner (1693–1742) fertig gestellte Providentia-Brunnen mit vier markanten Figuren, die die großen österreichischen Flüsse symbolisieren.

Le Marché à la farine de Vienne

Huile sur toile de Bernardo Bellotto, vers 1758/61

Le Neue Markt (nouveau marché) se trouve au cœur de la vieille ville de Vienne et depuis 1234, il est connu sous le nom de « Novum Forum » ou encore « Mehlmarkt ». La dernière dénomination vient du temps où le Neue Markt était un marché pour les céréales, la farine et les légumineuses, et qu'un grenier appelé « Mehlgrube » s'y trouvait, à gauche sur le tableau. Lorsque le commerce des céréales sur le Neue Markt devint insignifiant en raison de la nouvelle plaque tournante « am Schanzl » près du pont de la porte au Sel, sur la rive droite du Danube, la place garda malgré tout son nom, bien qu'un nouveau marché normal s'y soit dorénavant installé. Le grenier fut aménagé et devint une salle de bals et de concerts, dans laquelle de jeunes artistes comme Joseph Haydn, Mozart et plus tard aussi Ludwig van Beethoven s'y produisirent.

Le pôle attractif du Neue Markt est toutefois la fontaine Providentia, achevée en 1739 par Raphael Georg Donner (1693–1742), avec quatre figures marquantes qui symbolisent les grands fleuves autrichiens.

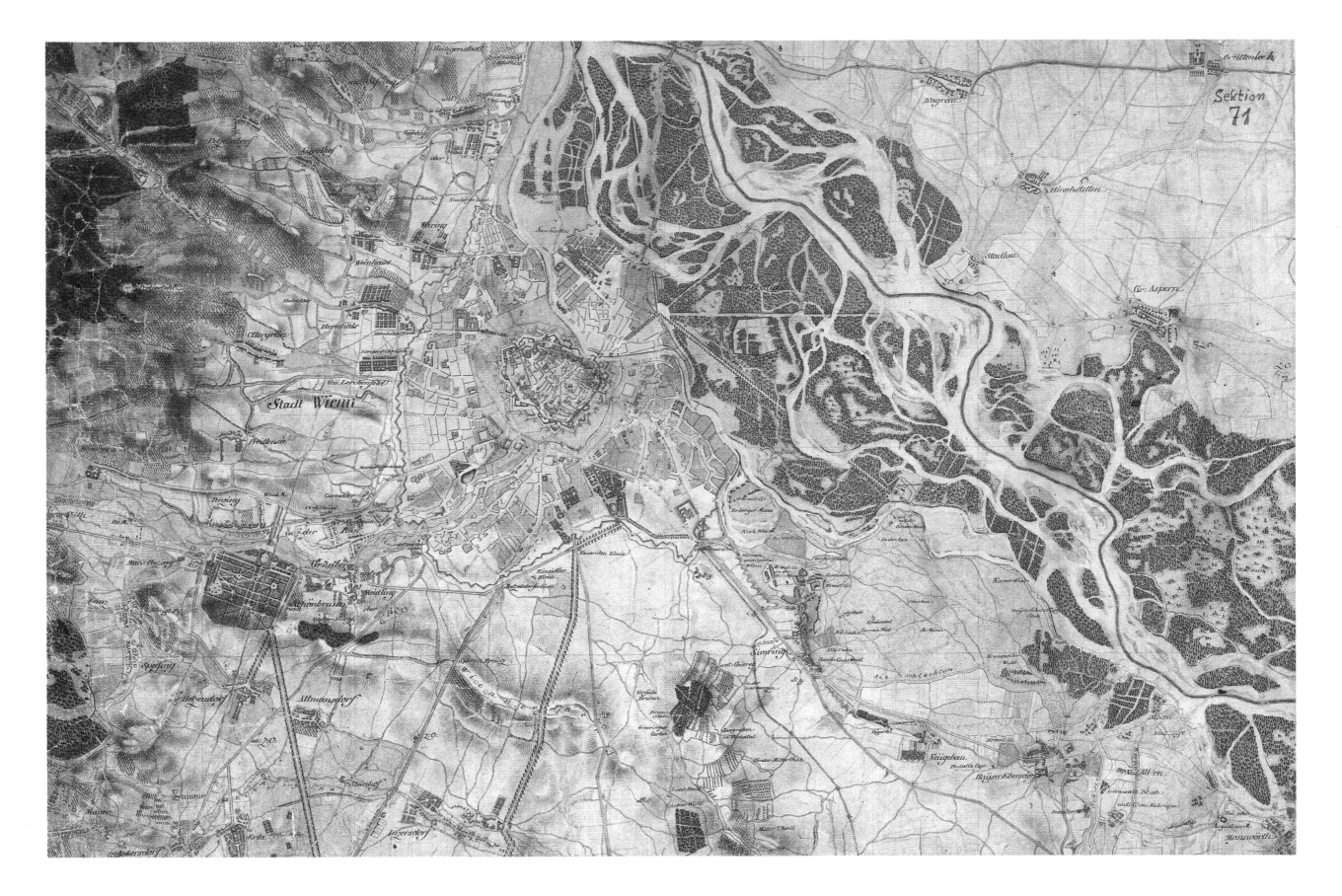

Josephine Survey Map of Vienna

Colored drawing, 18th century

This map forms part of the first systematic, cartographic survey of territories ruled and controlled by the Habsburgs and governed by hereditary princes from Austria. These so-called Habsburg Hereditary Lands included parts of contemporary Switzerland, Germany, France, Hungary, Italy, Slovenia, Croatia, and Austria. The Josephine survey maps were fashioned by engineers of the Royal War Council to provide accurate topographic data in the event of war, and it is for this reason that they were kept secret.

Josephinische Landesaufnahme von Wien

Kolorierte Handzeichnung, 18. Jahrhundert

Dieser Plan ist Teil der ersten planmäßigen kartographischen Erfassung der von den Habsburgern regierten und beherrschten Territorien, in denen Österreich den erblichen Fürsten stellte. Diese so genannten Habsburgischen Erblande bezogen sich zum Teil auf Gebiete der heutigen Schweiz, Deutschlands, Frankreichs, Ungarns, Italiens, Sloweniens, Kroatiens und Österreichs.
Die Karten der Josephinischen Landesaufnahmen wurden von Ingenieuren des Hofkriegsrates angefertigt, um im Falle eines Krieges genaue topographische Angaben zu haben; daher wurden sie geheim gehalten.

Mesurage de Vienne, dit « Josephinische Landesaufnahme »

Dessin manuscrit colorié, XVIIIᴱ siècle

Ce plan est une partie de la cartographie des territoires gouvernés et dominés par les Habsbourgs, dans lesquels l'Autriche a placé un prince héritier. Ces territoires héréditaires des Habsbourgs incluaient des régions des actuelles Suisse, Allemagne, France, Hongrie, Italie, Slovénie, Croatie et Autriche.
Les cartes du mesurage, dit « Josephinische Landesaufnahme », ont été réalisées par des ingénieurs du conseil de guerre de la cour, afin d'avoir des données topographiques précises en cas de guerre ; c'est pour cette raison qu'elles furent tenues secrètes.

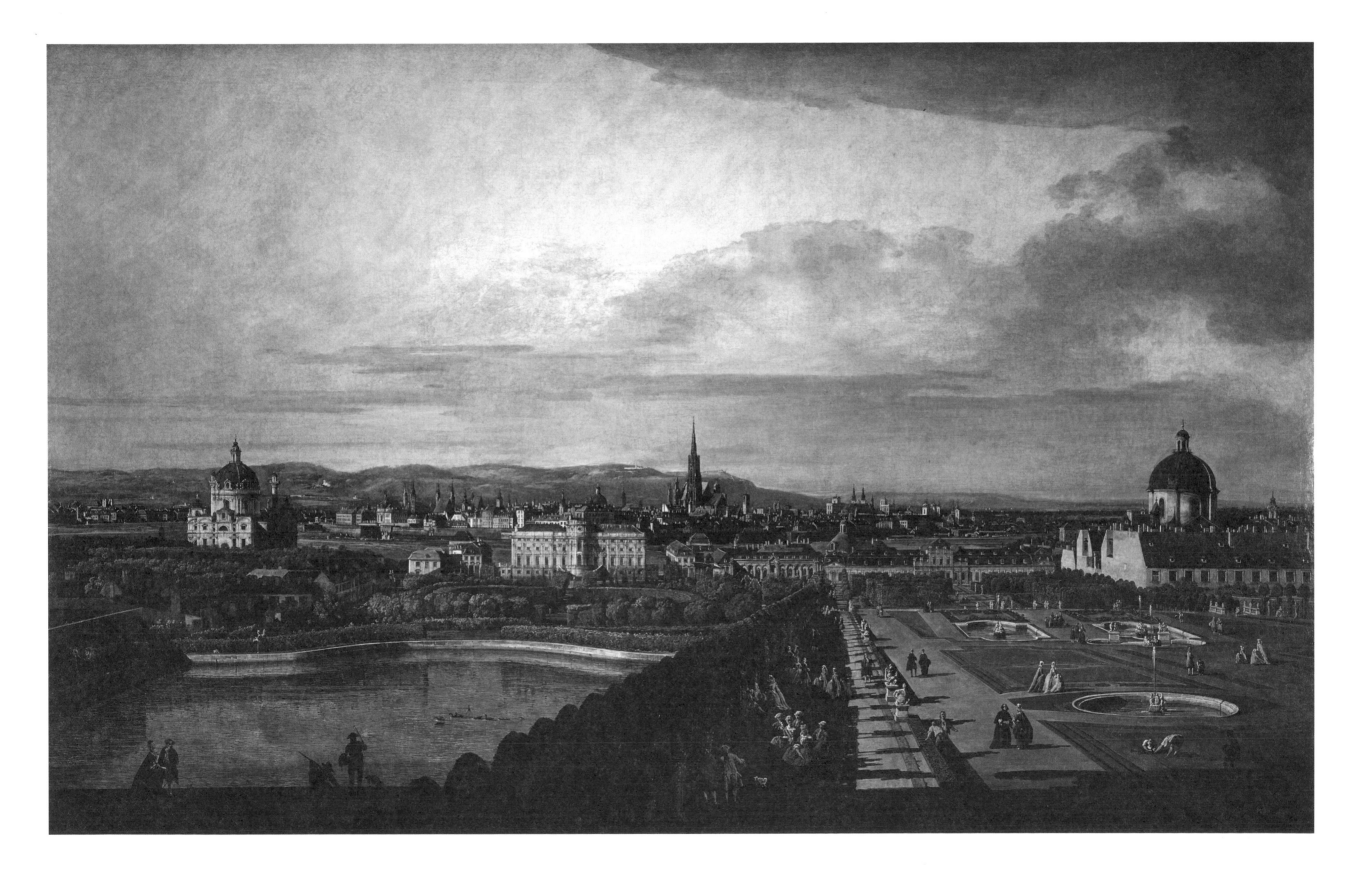

View of Vienna from the Belvedere

Oil on canvas by Bernardo Bellotto, circa 1759/61

The picture shows a view of Vienna from the Upper Belvedere with, from left to right, the Church of St. Charles, Schwarzenberg Palace, St. Stephen's Cathedral, and the Salesian Church.
Johann Lukas von Hildebrandt (1668–1745) built the garden palace that consists of two palaces, the Upper and Lower Belvedere. He was commissioned by Prince Eugen von Savoyen (1663–1736), one of Austria's most famous generals and also an art lover.
The Lower Belvedere mainly served as a residential palace, its design determined by its function. However, the Upper Belvedere took on a much more magnificent and lavish appearance than its lower counterpart: It is a representational structure used by the prince to receive his many guests, who often visited him in large numbers to attend his excessive and grandiose parties. A magnificently terraced garden connects the two palaces. The path between them is lined with sculptures arranged to symbolize the ascent from the underworld of the Lower Belvedere to the Olympus of the Upper Belvedere.
Originally situated just outside the city gates of Vienna, the garden palace is now located in Vienna's eastern downtown district and houses Austrian art from the Middle Ages to Modernity.

Wien vom Belvedere aus gesehen

Öl auf Leinwand von Bernardo Bellotto, um 1759/61

Das Bild zeigt den Blick vom Oberen Belvedere auf Wien mit der Karlskirche, dem Schwarzenberg-Palais, dem Stephansdom und der Salesianerkirche, von links nach rechts.
Johann Lukas von Hildebrandt (1668–1745) baute das aus zwei Schlössern bestehende Gartenpalais Oberes und Unteres Belvedere im Auftrag von Prinz Eugen von Savoyen (1663–1736), einem der berühmtesten Feldherren Österreichs und zugleich ein Kunstliebhaber.
Das Untere Belvedere diente vor allem als Wohnschloss und wurde funktional konzipiert. Hingegen wurde das Obere Belvedere weitaus prächtiger und aufwendiger gestaltet als sein darunter liegendes Pedant: Es ist ein Repräsentationsbau, der dem Prinzen als Empfangsraum für seine zahlreichen Gäste diente, die mit ihm dort oft in großer Zahl ausschweifende und pompöse Feste feierten. Ein prächtiger Terrassengarten verbindet die beiden Schlösser miteinander. Der Weg zwischen den beiden Anlagen ist eingerahmt von Skulpturen, die symbolisch den Weg als Aufstieg aus der Unterwelt des Unteren Belvedere in den Olymp des Oberen Belvedere gestalten.
Ursprünglich noch vor den Stadttoren Wiens gelegen, befindet sich das Gartenpalais nun im östlichen Innenbezirk Wiens und beherbergt österreichische Kunst vom Mittelalter bis zur Moderne.

Vienne, depuis le Belvédère

Huile sur toile de Bernardo Bellotto, vers 1759/61

Le tableau montre une vue sur Vienne depuis le Belvédère supérieur, avec, de gauche à droite, l'église Saint-Charles-Borromée, le palais Schwarzenberg, la cathédrale Saint-Étienne et l'église des Salésiens.
Johann Lukas von Hildebrandt (1668–1745) a construit le palais du Belvédère, constitué des châteaux inférieur et supérieur, à la demande du prince Eugène de Savoie (1663–1736), l'un des plus fameux généraux autrichiens et en même temps, grand amateur d'art.
Le Belvédère inférieur servait avant tout de résidence et fut conçu de manière fonctionnelle, tandis que pour l'aménagement du Belvédère supérieur, on fit preuve de bien plus de somptuosité et de détails que pour son pendant : il s'agit d'un édifice d'apparat, qui hébergeait les appartements destinés à recevoir les hôtes du prince, qui y célébraient souvent avec lui de multiples fêtes splendides et fastueuses. Un superbe jardin en terrasses relie les deux châteaux. Le chemin entre les deux est bordé d'une statuaire qui symbolise l'ascension depuis le bas-monde du Belvédère inférieur jusqu'à l'Olympe du Belvédère supérieur.
À l'origine situé devant les portes de Vienne, le palais se trouve à présent dans l'arrondissement du centre est de la ville et abrite une collection d'art autrichien du Moyen Âge à l'époque moderne.

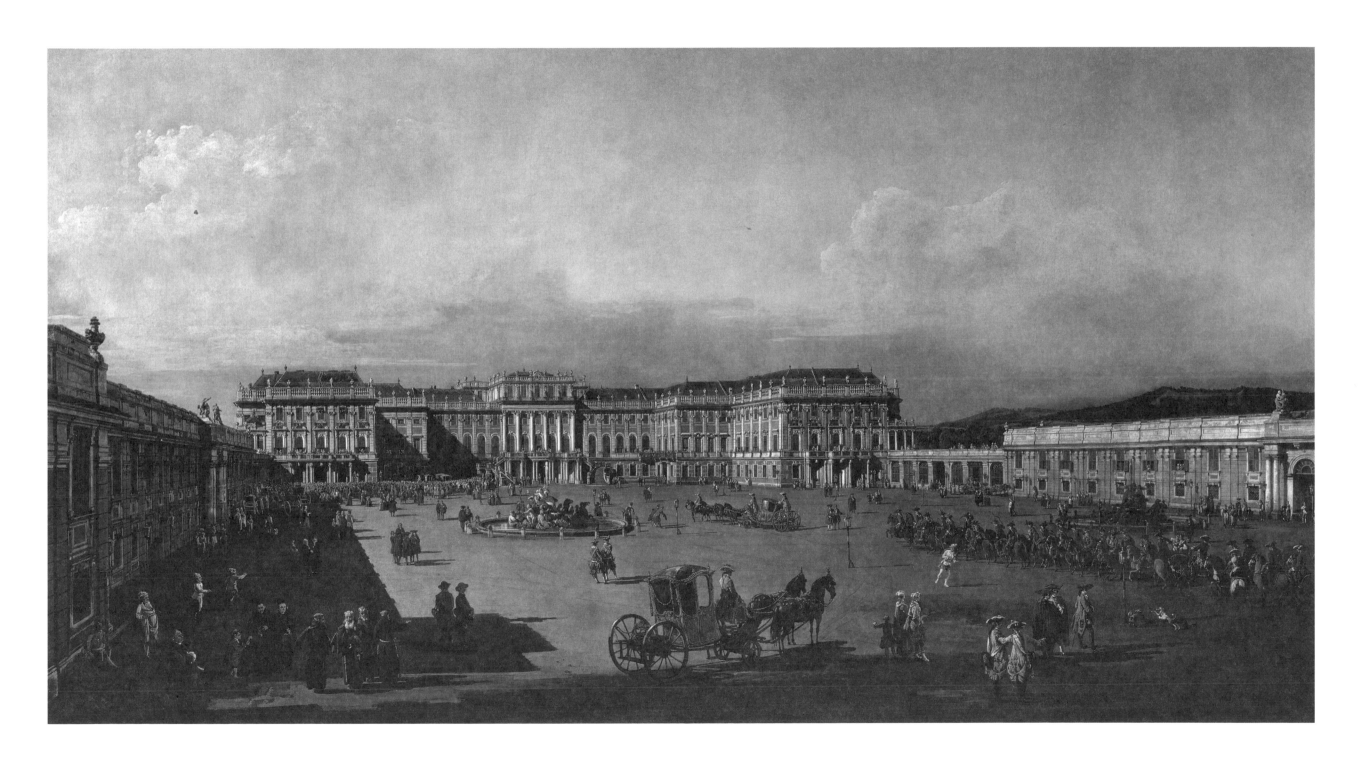

The Emperor's Summer Residence, Schönbrunn Palace, Courtyard Side

Oil on canvas by Bernardo Bellotto, 1759/61

Schönbrunn Palace is one of Vienna's top attractions. Although only a fraction of the palace's rooms are open to visitors, they can still sense the building's historical spirit: Emperor Franz Joseph I (1830–1916) was born here; he lived and died in the halls of this palace; at just six years of age, Mozart already played music in the Mirror Room; Maria Theresa held secret conferences in the Round Chinese Cabinet, and Napoleon (1769–1821) did so in the Vieux-Lacque Room; in 1814/15, the Congress of Vienna "danced" in the Great Gallery, and Emperor Charles I (1887–1922) ended the monarchy in the Blue Chinese Salon in 1918.

The facade is painted with the color traditional for Austrian representational architecture, a reddish shade of yellow, also called Schönbrunn yellow.

Bellotto's painting shows the arrival of Austrian Commander Franz Joseph Kinsky, Count of Wchinitz and Tettau (1736–1804), who in 1759 played an important part in the victory in the Battle of Kunersdorf during the Seven Year's War, when the Prussian Army under Frederick the Great (1712–1786) was defeated; in recognition for his services, the empress presented him with a valuable box and ring.

Das kaiserliche Lustschloss Schloss Schönbrunn, Hofseite

Öl auf Leinwand von Bernardo Bellotto, 1759/61

Das Schloss Schönbrunn ist eines der meistbesuchten Attraktionen Wiens. Obwohl nur ein Bruchteil der Räume des Schlosses besichtigt werden kann, spürt der Besucher den historischen Geist des Gebäudes: Kaiser Franz Joseph I. (1830–1916) wurde hier geboren, lebte und starb in den Räumen des Schlosses; im Spiegelsaal musizierte bereits Mozart als Sechsjähriger; Maria Theresia hielt im Chinesischen Rundkabinett und Napoléon (1769–1821) im Vieux-Lacque-Zimmer geheime Konferenzen ab; in der Großen Galerie »tanzte« der Wiener Kongress 1814/15, und im Blauen Chinesischen Salon beendete Kaiser Karl I. (1887–1922) im Jahr 1918 die Monarchie.

Die Fassade zeigt sich in der traditionellen Farbe der österreichischen Repräsentationsarchitektur, einem rötlichen Gelb, auch Schönbrunnergelb genannt.

Bellotto zeigt auf seinem Bild die Ankunft des österreichischer Feldmarschalls Franz Joseph Kinsky Graf zu Wchinitz und Tettau (1736–1804), der einen wesentlichen Anteil am Sieg um die Schlacht bei Kunersdorf 1759 im Rahmen des Siebenjährigen Krieges hatte, als die preußische Armee unter Friedrich dem Großen (1712–1786) besiegt wurde, und deshalb von der Kaiserin mit einer kostbaren Dose und einem Ring beschenkt wurde.

Le château impérial d'agrément de Schönbrunn, côté cour

Huile sur toile de Bernardo Bellotto, 1759/61

Le château de Schönbrunn est l'un des sites les plus visités de Vienne. Bien que seule une infime partie des pièces du château puisse être vues, le visiteur ressent encore l'esprit historique qui l'habite : l'empereur François-Joseph Ier (1830–1916) est non seulement né ici, mais il a vécu et est mort dans les appartements du château ; dans la salles des Glaces, Mozart âgé de six ans y joua déjà ; Marie-Thérèse a tenu des conférences secrètes dans le cabinet circulaire chinois et Napoléon (1769–1821) dans le salon Vieux-Lacque ; dans la grande galerie, le congrès de Vienne « dansa » en 1814–1815, et l'empereur Charles Ier (1887–1922) décréta en 1918 la fin de la monarchie dans le salon chinois bleu.

La façade exhibe la couleur traditionnelle de l'architecture d'apparat autrichienne, un jaune ocre, aussi nommé jaune Schönbrunn.

Sur son tableau, Bellotto montre l'arrivée du feldmarschall Franz Joseph Kinsky Graf zu Wchinitz und Tettau (1736–1804) que l'impératrice récompense avec une boîte précieuse et une bague, pour avoir grandement concouru à la victoire lors de la bataille de Kunersdorf en 1759 dans le cadre de la guerre des Sept Ans, lorsque l'armée prussienne sous Frédéric le Grand (1712–1786) fut défaite.

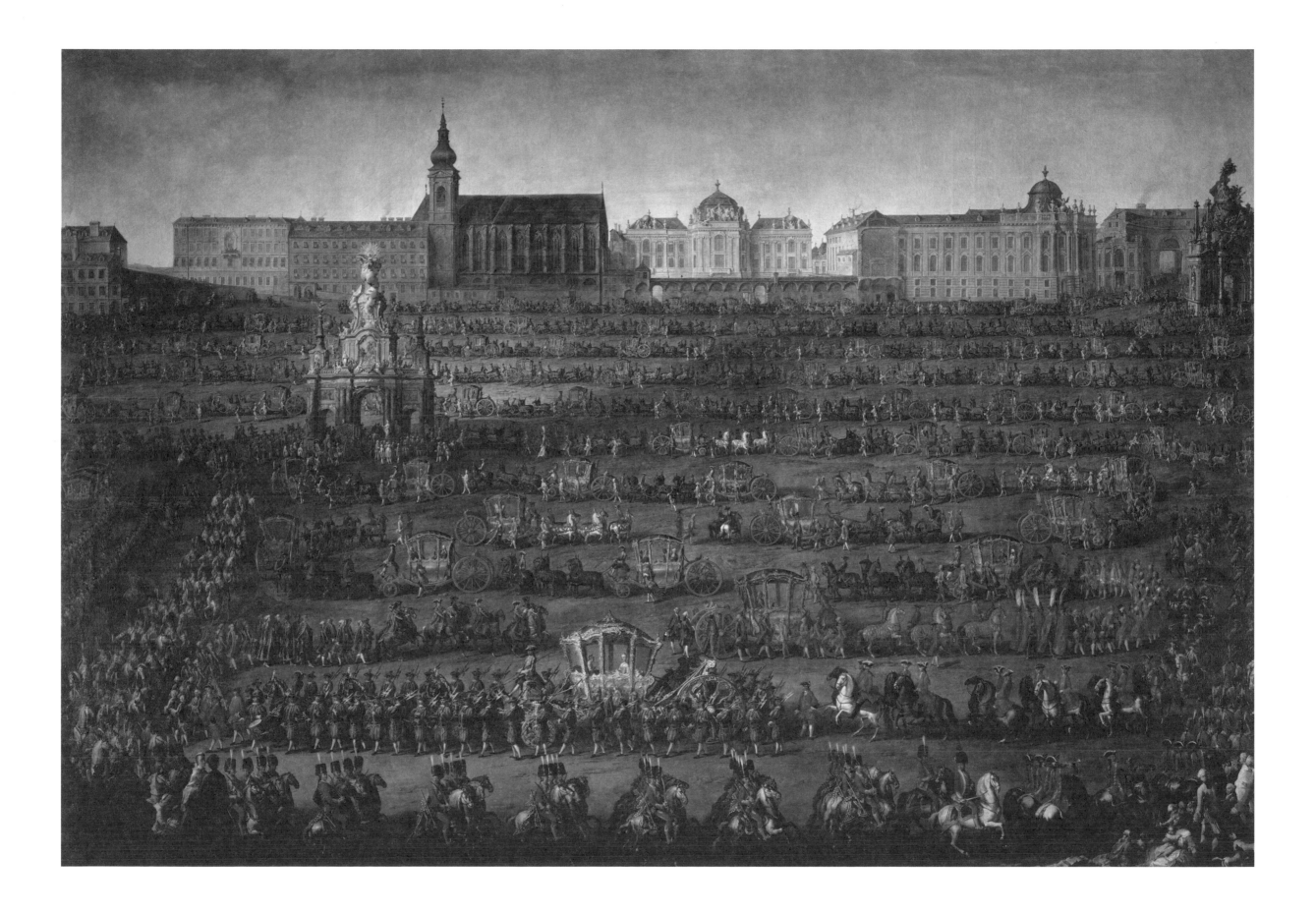

The Bride's Ceremonial Entry into Vienna

Oil on canvas by Martin van Meytens and his workshop, circa 1760/65

The subject of this picture is the imposing procession of French Isabella of Bourbon-Parma (1741–1763), who is moving to Vienna to marry the Archduke and later Emperor Joseph II in October 1760. Although the marriage of Joseph's mother Maria Theresa had been arranged for political reasons, Joseph II apparently felt deep affection for his wife, so that after her death and the death of their two daughters, who died at age eight and during childbirth, he withdrew from public life.
The so-called Golden Carriage conveying Isabella from Parma to Vienna can be seen in the central foreground of the picture. Originally made for Prince Joseph Wenzel I of Liechtenstein (1696–1772), the carriage was a technological and stylistic novelty: more than six meters high, over two meters wide and three meters deep, made of wood, steel, and gilded bronze, its interior furnished with leather and velvet decorated with gold embroidery, brocade, and crystal – an expression of the owner's wealth and the feudal way of life. The carriage stood the test of time and can still be admired today in Vienna's Liechtenstein Museum.

Der Einzug der Braut in Wien

Öl auf Leinwand von Martin van Meytens und seiner Werkstatt, um 1760/65

Der imposante Einzug der Französin Isabella von Bourbon-Parma (1741–1763) in Wien zur Hochzeit mit dem Erzherzog und späteren Kaiser Joseph II. im Oktober 1760 ist Thema dieses Bildes. Obwohl die Hochzeit von Josephs Mutter Maria Theresia aus politischem Kalkül arrangiert worden war, soll Joseph II. große Zuneigung für seine Gemahlin empfunden haben und sich nach ihrem sowie dem Tod ihrer beiden Töchter, die im Alter von acht Jahren und bei der Geburt starben, aus der Öffentlichkeit zurückgezogen haben.
Der so genannte Goldene Wagen, in dem Isabella aus Parma nach Wien gefahren wurde, hier in der Bildmitte im Vordergrund, wurde ursprünglich für den Fürsten Josef Wenzel I. von Liechtenstein (1696–1772) angefertigt und stellte technisch und stilistisch eine Neuheit dar: über sechs Meter hoch, mehr als zwei Meter breit und drei Meter tief, gefertigt aus Holz, Stahl und vergoldeter Bronze, innen ausgestattet mit Leder und Samt mit Goldstickerei, Brokat und Kristall – Ausdruck des Reichtums des Besitzers sowie der feudalen Lebensweise. Der Wagen hat die Zeit überdauert und kann heute noch im Liechtenstein Museum in Wien bewundert werden.

L'arrivée de la fiancée à Vienne

Huile sur toile de Martin van Meytens et son atelier, vers 1760/65

L'imposante arrivée à Vienne de la Française Isabelle de Bourbon-Parme (1741–1763) à l'occasion de son mariage avec l'archiduc et futur empereur Joseph II en octobre 1760 est le sujet de ce tableau. Bien que le mariage ait été le fruit de calculs politiques de sa mère Marie-Thérèse, il semblerait que Joseph II ait éprouvé une grande attirance pour sa femme et qu'il se soit retiré de la vie publique à sa mort et à celle de ses deux filles, à l'âge de huit ans et à la naissance.
Le carrosse d'or, dans lequel Isabelle de Parme fut conduite à Vienne, visible ici au premier plan, fut à l'origine fabriqué pour le prince Josef Wenzel I er de Liechtenstein (1696–1772). Sur le plan technique et stylistique, il s'agissait d'une innovation : plus de six mètres de haut, plus de deux mètres de largeur et trois mètres de profondeur, réalisé en bois, acier et bronze doré, avec un intérieur en cuir et velours avec des broderies d'or, du brocart et du cristal, c'était un témoignage de la richesse de son possesseur, mais aussi d'une vie féodale. La voiture a survécu au temps et peut être aujourd'hui encore admirée au musée du Liechtenstein à Vienne.

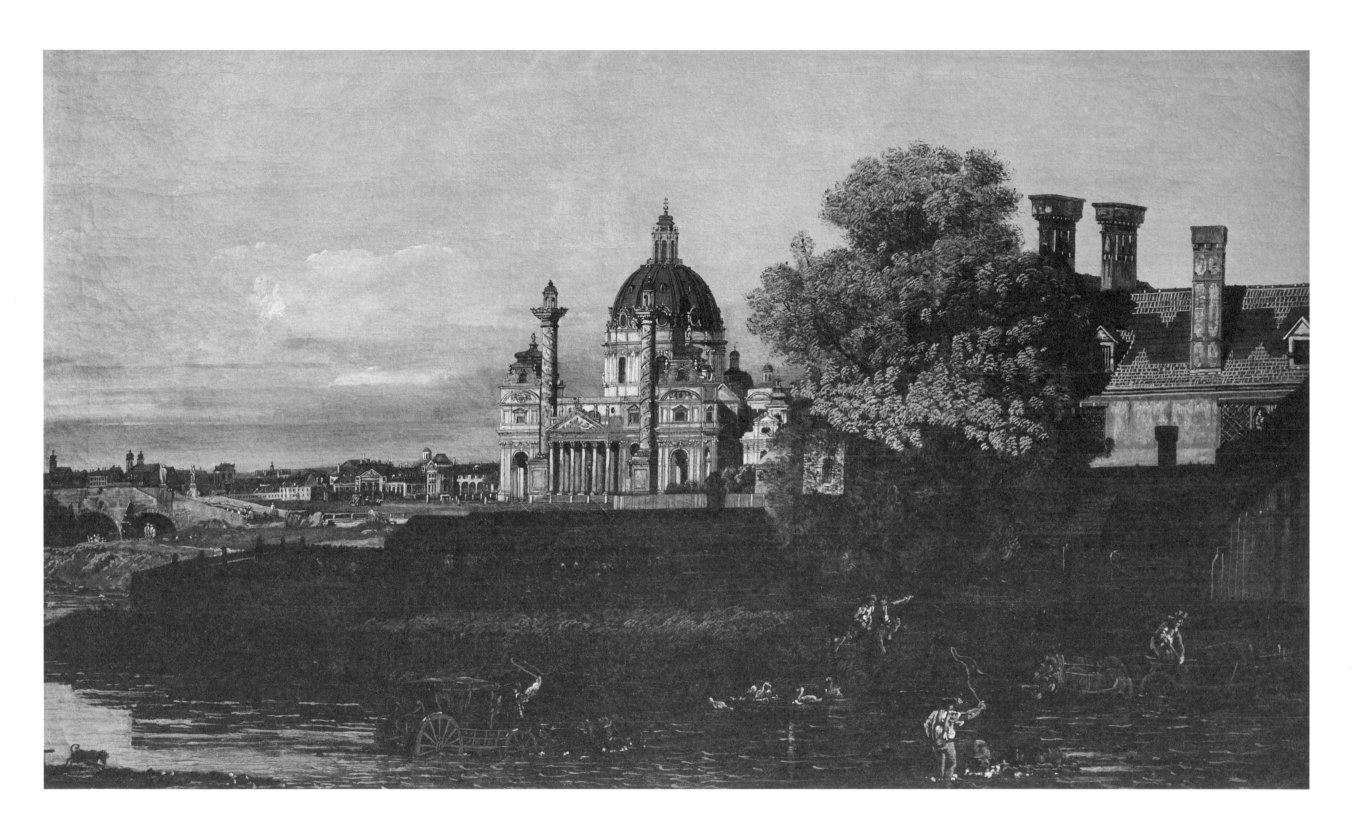

View of the Church of St. Charles in Vienna

Oil on canvas by Bernardo Bellotto, circa 1759/61

The Church of St. Charles is a striking and imposing ecclesiastical structure with a 72-meter-high dome that was the last great work by Baroque architect Johann Bernhard Fischer von Erlach (1656–1723). After his death, his son Joseph Emanuel (1693–1742) completed the building. The Church of St. Charles combines various architectural styles from different countries: The triumphal columns to the right and left of the entrance were borrowed from Roman architecture, but their decor recalls the Islamic minaret. Its central facade is borrowed from Greek temple architecture while its flanking chapels can be classified as Italian Renaissance. The roof looks like a Chinese pagoda.

Bellotto selected a view of the Church of St. Charles as seen from Vienna's left bank, which at the time was still an undeveloped wooded area. Visible to the left of the Church of St. Charles is a wing of the Schwarzenberg Garden Palace, completed by Johann Bernhard with his son Joseph Emanuel Fischer von Erlach after the death of Johann Lukas von Hildebrandt.

Ansicht der Karlskirche in Wien

Öl auf Leinwand von Bernardo Bellotto, um 1759/61

Die Karlskirche ist ein auffälliger und imposanter Sakralbau mit einer 72 Meter hohen Kuppel und zugleich das letzte große Werk des barocken Architekten Johann Bernhard Fischer von Erlach (1656–1723). Nach seinem Tod vollendete sein Sohn Joseph Emanuel (1693–1742) den Bau.

Die Karlskirche vereint unterschiedliche Architekturstile aus verschiedenen Ländern: Die Triumphsäulen rechts und links des Eingangs sind der römischen Architektur entlehnt, erinnern jedoch in der Art der Darstellung an islamische Minarette. Die Mittelfront ist einem griechischen Tempel nachempfunden, während die Seitenkapellen der italienischen Renaissance zuzuordnen sind. Das Dach wirkt wie das einer chinesischen Pagode.

Bellotto wählte die Ansicht der Karlskirche vom linken Donau-Ufer, das damals noch bewaldet und unbebaut war. Links neben der Karlskirche ist ein Flügel des Gartenpalais Schwarzenberg zu erkennen, das Vater Johann Bernhard und Sohn Joseph Emanuel Fischer von Erlach nach dem Tod von Johann Lukas von Hildebrandt fertig stellten.

Vue de l'église Saint-Charles-Borromée de Vienne

Huile sur toile de Bernardo Bellotto, vers 1759/61

L'église Saint-Charles-Borromée est un édifice sacré ostensible et imposant, avec une coupole de 72 mètres de hauteur, et en même temps, la dernière grande œuvre de l'architecte baroque Johann Bernhard Fischer von Erlach (1656–1723). Après sa mort, son fils Joseph Emanuel (1693–1742) en acheva la construction.

L'église Saint-Charles-Borromée associe différents styles architecturaux de différents pays : les colonnes triomphales à droite et à gauche de l'entrée sont empruntées à l'architecture romaine, rappellent toutefois des minarets musulmans. La façade est apparentée à la forme d'un temple grec, tandis que les chapelles latérales peuvent être attribuées à la Renaissance italienne. Leur toit évoque celui d'une pagode chinoise.

Bellotto a choisi la vue de l'église depuis la rive gauche de Vienne qui, à l'époque, était encore boisée et non bâtie. À gauche à côté de l'église, on reconnaît une aile du palais Schwarzenberg, achevé à la mort de Johann Lukas von Hildebrandt par Johann Bernhard Fischer von Erlach et son fils Joseph Emanuel.

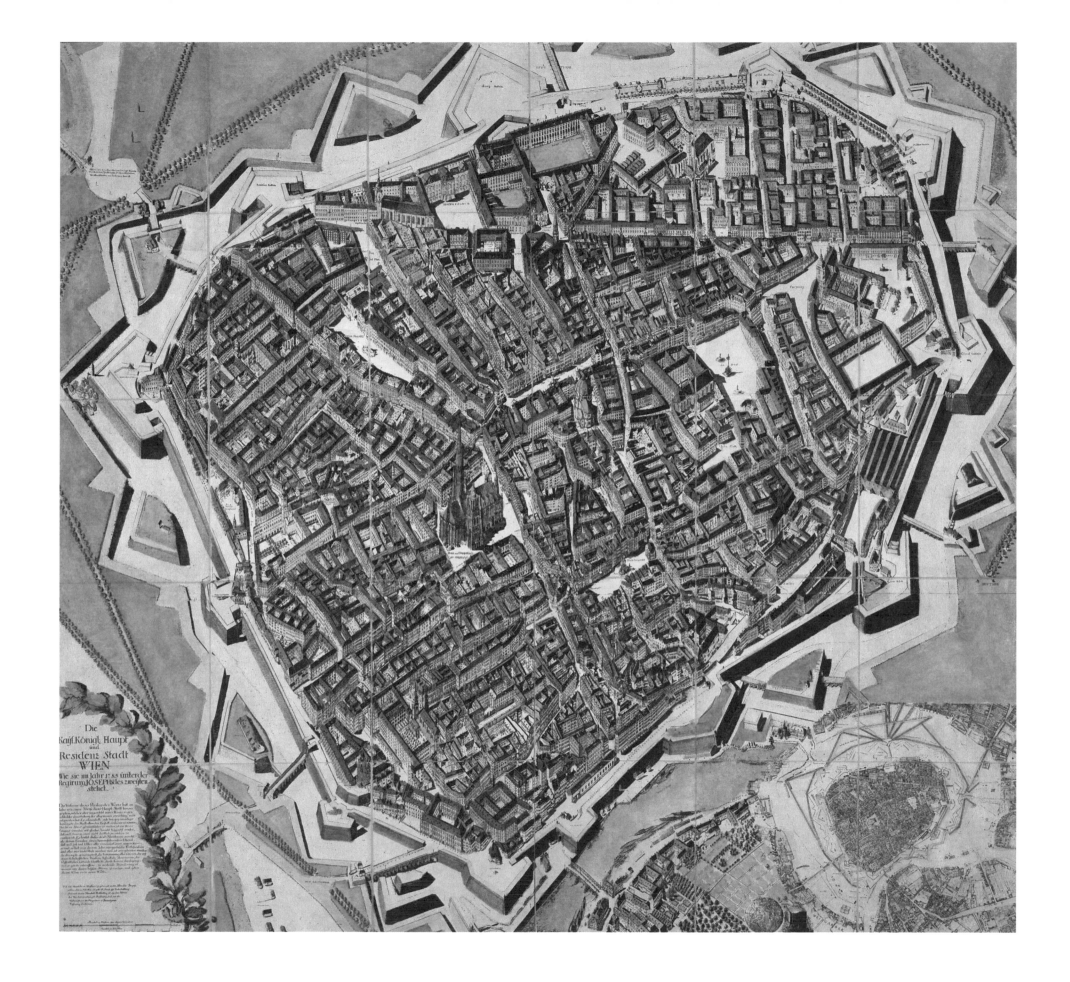

Scenography or Geometric, Perspectival Representation of the Imperial and Royal Capital and Residence City of Vienna, Austria

Colored copper engraving by Josef Daniel von Huber, 1769/74

This perspectival depiction of Vienna with its suburbs was made by military cartographer Joseph Daniel von Huber (1730/31–1788) by order of Empress Maria Theresa. He did his work using the so-called military perspective according to which buildings – true to the scale of their real height and with accurately detailed facades – were positioned on the city's ground plan. The accomplished perspectivism and neatness of detail revealed in this map was unparalleled at its time. Visible above the southern tower of St. Stephen's Cathedral in the city center is Magdalena Chapel, which burnt down in September 1781, a few years after this map was completed. Virgil Chapel, situated beneath, has, however, survived.

Scenographie oder Geometrisch Perspect. Abbildung der Kayl. Königl. Haupt u. Residenz Stadt Wienn in Oesterreich

Kolorierter Kupferstich von Josef Daniel von Huber, 1769/74

Diese Perspektivdarstellung von Wien mit seinen Vorstädten fertigte der Militärkartograph Joseph Daniel von Huber (1730/31–1788) im Auftrag der Kaiserin Maria Theresia an. Dabei arbeitete er nach der so genannten Militärperspektive, bei der auf dem Grundriss der Stadt die Gebäude maßstabsgetreu mit ihrer wirklichen Höhe und originalgetreuen Fassade aufgetragen werden. Die perspektivische und detailgetreue Darstellung dieses Plans suchte seinerzeit ihresgleichen. Über dem Südturm des Stephansdoms im Zentrum der Stadt steht noch die Magdalenenkapelle, die wenige Jahre nach Anfertigung dieser Karte, im September 1781, abbrannte. Dagegen ist die unterirdisch liegende Virgilkapelle erhalten geblieben.

Scénographie ou représentation en perspective de la capitale et ville de résidence royale et impériale de Vienne en Autriche

Gravure sur cuivre coloriée de Josef Daniel von Huber, 1769/74

La représentation en perspective de Vienne avec ses faubourgs a été réalisée par le cartographe militaire Joseph Daniel von Huber (1730/31–1788) à la demande de l'impératrice Marie-Thérèse. Il travailla pour cela selon la perspective dite militaire, les bâtiments étant rapportés à l'échelle exacte sur le plan de la ville avec leur hauteur précise et les façades fidèlement reproduites. La représentation en perspective et détaillée de ce plan n'a pas son pareil à l'époque. Au-dessus de la tour sud de la cathédrale Saint-Étienne au centre de la ville, on reconnaît la chapelle Sainte-Madeleine qui a brûlé peu après l'achèvement de cette carte, en septembre 1781. En revanche, la chapelle Saint-Virgile, que l'on a retrouvée au-dessous, a été épargnée.

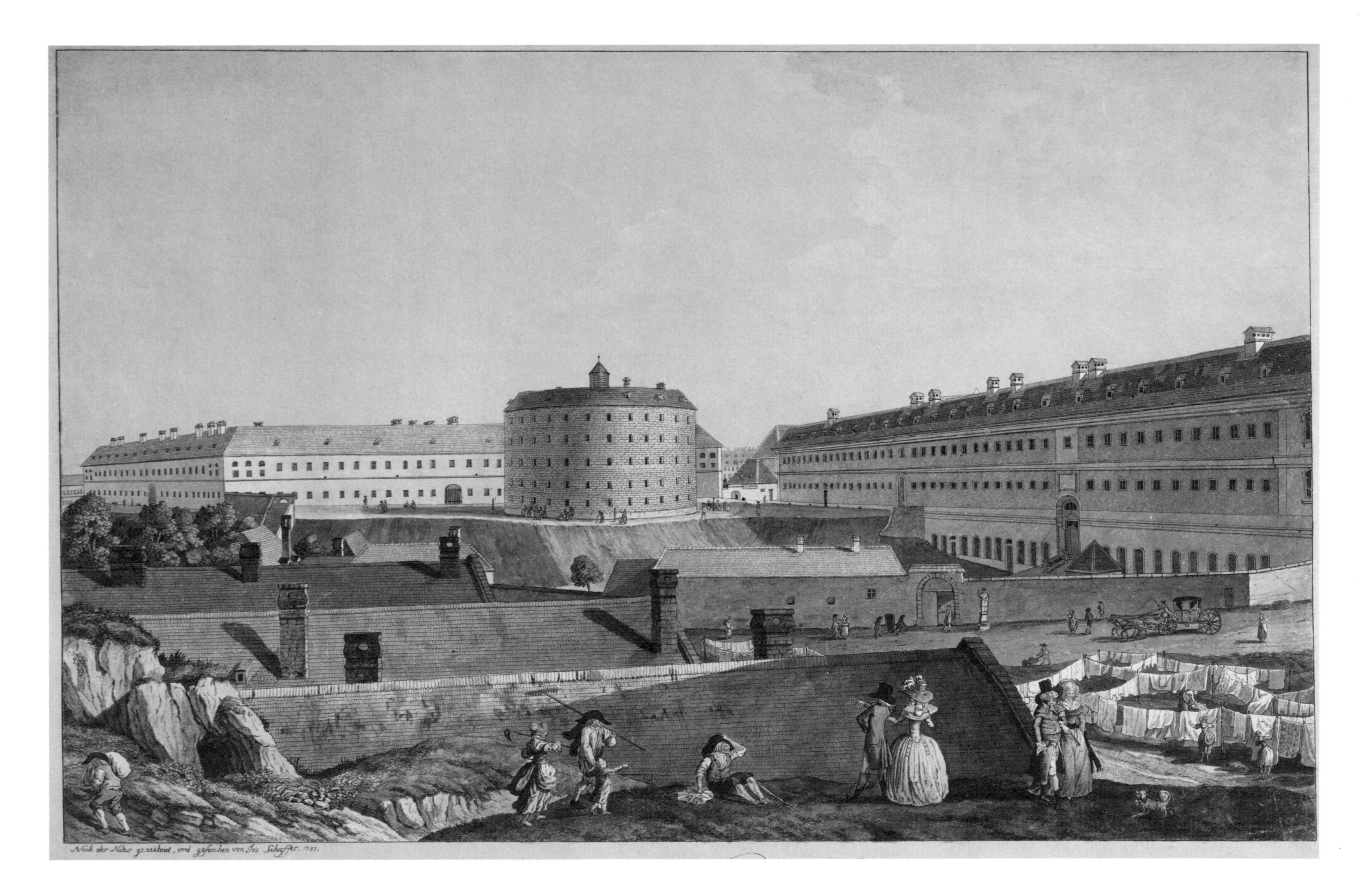

Nach der Natur gezeichnet, und gestochen von Jos Schaffer. 1787.

General Hospital, View of the Madhouse Tower and the General and Military Hospital seen from the back

COLORED COPPER ENGRAVING BY JOSEPH SCHAFFER, 1787

In 1693, Emperor Leopold I founded the Home for the Poor and Disabled, which after three years already housed more than 1,000 poor people. Barely one hundred years later, Emperor Joseph II (1741–1790) reformed healthcare. He established a state training center for doctors. By renovating the Home for the Poor, he also founded Vienna's General Hospital, which was one of his pet projects. The official opening of this huge new complex took place on August 16, 1784.

The engraving shows the so-called Madhouse Tower in the center, a circular five-story building similar to a fortress with 28 rooms and slit-like windows. The building accommodates as many as 250 mental patients. Today, the tower houses the Federal Pathologic-Anatomical Museum. The old hospital building is mainly used by the university.

Allgemeines Krankenhaus, Ansicht des Narrnthurms, dan des Universal- und Militaire-Spitals von der Rueckseite

KOLORIERTER KUPFERSTICH VON JOSEPH SCHAFFER, 1787

Kaiser Leopold I. gründete im Jahr 1693 das »Großarmen- und Invalidenhaus«, das schon nach drei Jahren mehr als 1000 arme Menschen beherbergte. Kaiser Joseph II. (1741–1790) bemühte sich ein knappes Jahrhundert später um Reformen des Gesundheitswesens. Er veranlasste eine staatliche Ausbildungsstätte für Ärzte sowie durch Umgestaltung des Armenhauses die Errichtung des Wiener Allgemeinen Krankenhauses, was für ihn eine Art Lieblingsprojekt darstellte. Die offizielle Eröffnung dieses riesigen neuen Komplexes fand am 16. August 1784 statt.

Der Stich zeigt in der Mitte den so genannten Narrenturm, einen fünfstöckigen, festungsähnlichen Rundbau mit 28 Räumen und schlitzartigen Fenstern. Hier waren bis zu 250 Geisteskranke untergebracht. Heute residiert das Pathologisch-anatomische Bundesmuseum im Narrenturm, das alte Krankenhausgebäude wird vorrangig von der Universität genutzt.

Hôpital général, Vue de la tour des fous, de l'hôpital universel et militaire depuis l'arrière

GRAVURE SUR CUIVRE COLORIÉE DE JOSEPH SCHAFFER, 1787

L'empereur Léopold Ier fonda en 1693 l'« Asile des grands pauvres et des invalides », qui hébergeait déjà trois ans après plus de 1000 pauvres. L'empereur Joseph II (1741–1790) s'efforça un siècle plus tard d'effectuer des réformes du système de santé publique. Il instaura un centre de formation d'état ainsi que la création de l'hôpital général viennois en réaménageant l'hospice, ce qui semblait être pour lui devenir un projet favori. L'inauguration officielle de cet immense et nouveau complexe eut lieu le 16 août 1784.

Au milieu, la gravure montre la tour dite des fous (Narrenturm), un bâtiment circulaire semblable à une forteresse à cinq étages, 28 salles et meurtrières. Ici étaient abrités jusqu'à 250 malades mentaux. Aujourd'hui, elle abrite le Musée national de pathologie et d'anatomie, l'ancien bâtiment de l'hôpital étant principalement utilisé par l'Université.

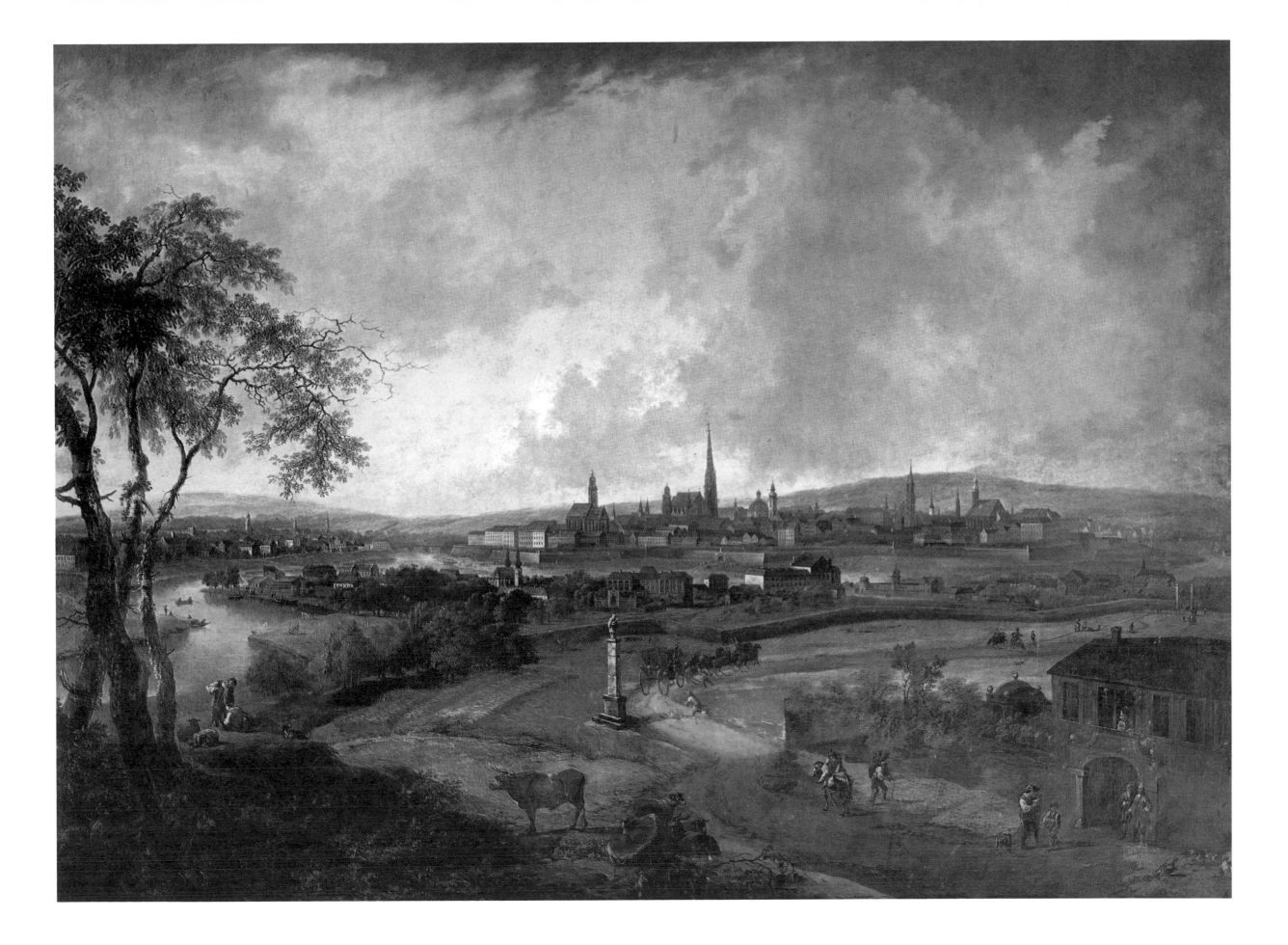

A View from the Prater in the Direction of the Landstrasse District

Oil on canvas by Joseph Heideloff, circa 1780

Situated on an island between the Danube and the Danube Canal in Vienna's second municipal district, Leopoldstadt, the Viennese Prater is a park whose landscape takes up the largest part of the district. Its name apparently goes back to the late 12th century when Babenberg Duke Frederick I of Austria (1175–1198) granted a few meadows in the wetlands area to the de Prato family. Initially an imperial hunting ground with access limited to the nobility, the Prater was first opened to ordinary people in the form of a small, modest restaurant with a bowling alley established on the Prater's edge in 1603. When in 1766 Emperor Joseph II declared the area a recreational preserve for everyone, the Prater with its coffee houses, swings, and merry-go-rounds quickly turned into the most popular day-trip destination for the Viennese and their guests.

Upon occasion of the 50th anniversary of the reign of Emperor Franz Joseph I, the giant Viennese Ferris wheel was installed that has since become a symbol of Vienna. Its fifteen gondolas offer visitors a fantastic view of Vienna.

Eine Aussicht im Prater gegen die Vorstadt Landstrasse

Öl auf Leinwand von Joseph Heideloff, um 1780

Der Wiener Prater, auf einer Insel zwischen Donau und Donaukanal im 2. Wiener Gemeindebezirk Leopoldstadt gelegen, nimmt als Parklandschaft den größten Teil des Bezirks ein. Der Name geht vermutlich auf die Familie de Prato zurück, die Ende des 12. Jahrhunderts vom Babenberger Herzog Friedrich I. von Österreich (1175–1198) einige Wiesen der Auenlandschaft zum Geschenk erhielten. Erst kaiserliches Jagdrevier und nur dem Adel zugänglich, eröffnete 1603 ein kleines bescheidenes Lokal mit einer Kegelbahn am Rande des Praters für das gemeine Volk. Als Kaiser Joseph II. im Jahr 1766 das Gebiet als frei zugängliches Erholungsgebiet öffnete, entwickelte sich der Prater mit seinen Caféhäusern, Schaukeln und Karussellen schnell zum beliebtesten Ausflugsziel der Wiener und ihrer Besucher.

Zum 50. Thronjubiläum von Kaiser Franz Joseph I. wurde das mittlerweile zum Wahrzeichen avancierte Wiener Riesenrad errichtet, das aus seinen fünfzehn Gondeln eine fantastische Aussicht über Wien bietet.

Une vue du Prater vers la banlieue Landstrasse

Huile sur toile de Joseph Heideloff, vers 1780

Situé sur une île entre Danube et canal du Danube dans Leopoldstadt, le 2ᵉ arrondissement de la ville, le Prater viennois est un vaste parc qui recouvre la majeure partie de cet arrondissement. Son nom remonte probablement à la famille de Prato, qui reçut en donation à la fin du XIIᵉ siècle quelques prés de la plaine alluviale de la part du duc Frédéric Iᵉʳ de Babenberg (1175–1198). Tout d'abord chasse impériale et uniquement accessible à la noblesse, en 1603 ouvrit à la périphérie du Prater une modeste petite auberge avec un jeu de quilles pour le menu peuple. Lorsque, en 1766, l'empereur Joseph II instaura la liberté d'accès à cette zone de repos, le Prater, avec ses cafés, ses balançoires et carrousels, devint rapidement le but d'excursion favori des Viennois et de leurs visiteurs.

À l'occasion du 50ᵉ anniversaire du couronnement de l'empereur François-Joseph fut érigée la grande roue, devenue entre-temps emblème de Vienne, et dont les quinze gondoles offrent une vue fantastique sur la ville.

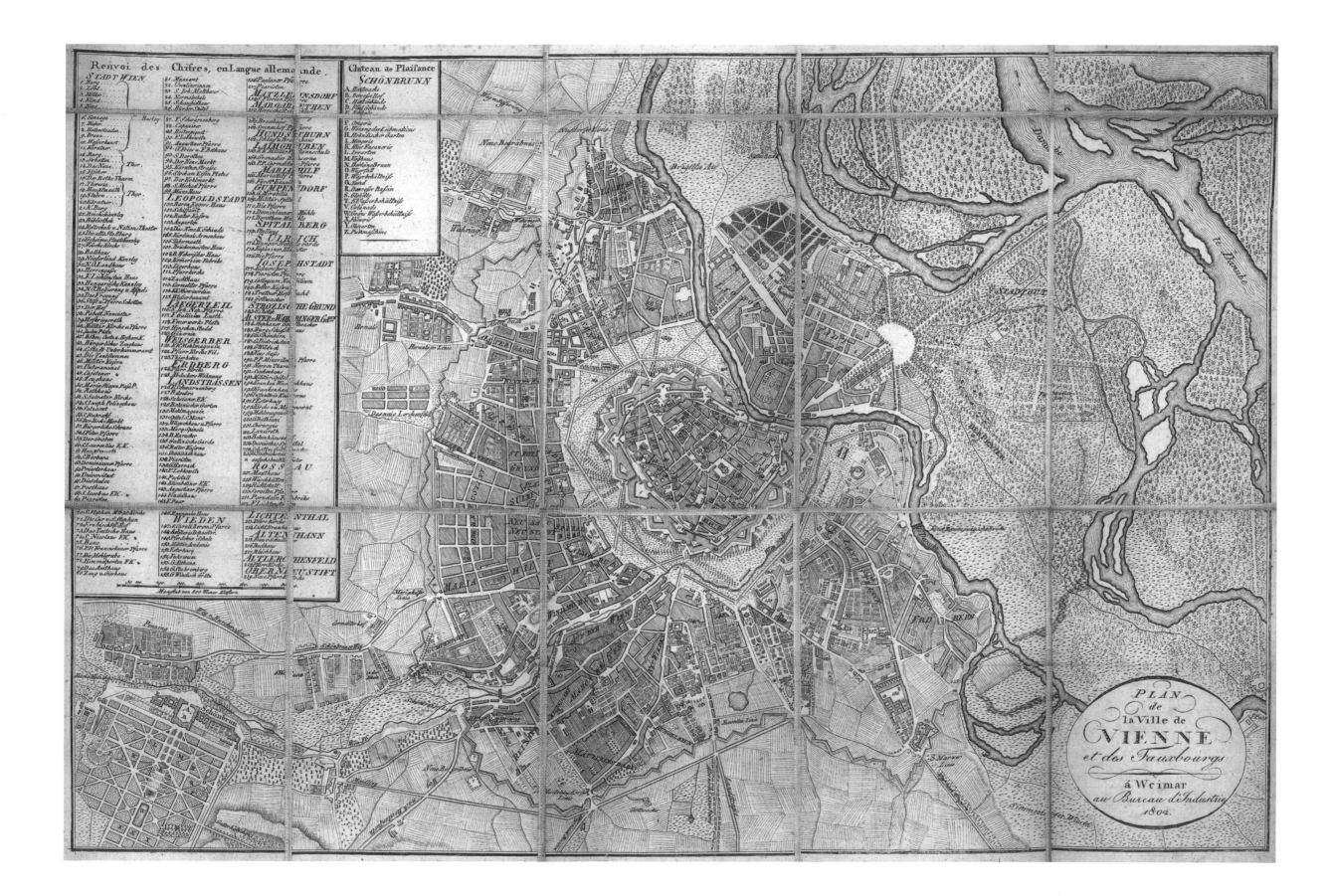

Renvoi des Chifres, en Langue allemande.

Château de Plaisance SCHÖNBRUNN

PLAN de la Ville de VIENNE et des Fauxbourgs à Weimar au Bureau d'Industrie 1802

Map of Vienna and Its Suburbs

Copper engraving, Bureau d'Industrie, Weimar 1802

When Emperor Franz II abdicated the crown of the Holy Roman Emperor of the German Nation in August 1806, he also initiated the end of the empire.
Many officials left Vienna. But because of increasing industrialization and the attendant influx of new workers, the city's population continued to grow. In 1850, the villages and suburbs outside the city gates were incorporated; the result was that the population soon increased to over 410,000. Since many streets, alleys and squares suddenly had the same name, starting in 1862 many names were changed.
In 1870, the population had already doubled, and in 1880 the city of Vienna had more than 1,100,000 residents.

Stadtplan der Stadt Wien und der Vororte

Kupferstich, Bureau d'Industrie, Weimar 1802

Als Kaiser Franz II. im August 1806 die Reichskrone des Heiligen Römischen Reiches Deutscher Nation niederlegte, bedeutete dies auch das Ende des Reiches. Zahlreiche Beamte wanderten aus Wien ab. Doch durch die verstärkt einsetzende Industrialisierung und den damit verbundenen Zuzug von neuen Arbeitskräften wuchs die Stadtbevölkerung weiter an. 1850 wurden die Dörfer und Vororte vor den Toren der Stadt eingemeindet mit der Folge, dass die Einwohnerzahl bald auf über 410 000 stieg. Da zahlreiche Straßen, Gassen und Plätze plötzlich denselben Namen trugen, wurden ab 1862 viele Umbenennungen durchgeführt.
1870 hatte sich die Einwohnerzahl bereits verdoppelt, und 1880 zählte man auf dem Gebiet der Stadt Wien über 1 100 000 Einwohner.

Plan de la ville de Vienne et des fauxbourgs

Gravure sur cuivre, Bureau d'Industrie, Weimar 1802

Lorsque l'empereur François II en août 1806 déposa la couronne du Saint-Empire romain germanique, cela signifiait aussi la fin de l'Empire.
De nombreux fonctionnaires tournèrent le dos à Vienne. Néanmoins, avec les débuts soutenus de l'industrialisation et l'afflux d'une nouvelle main-d'œuvre qui les accompagnait, la population de Vienne continua à augmenter. En 1850, les villages et faubourgs aux portes de la ville furent annexés, le nombre des habitants passant bientôt à plus de 410 000. Comme nombre de rues, de ruelles et de places portaient soudain le même nom, de nombreux changements de noms eurent lieu à partir de 1862.
En 1870, le nombre des habitants avait déjà doublé et en 1880, on comptait sur le territoire de la ville de Vienne plus de 1 100 000 habitants.

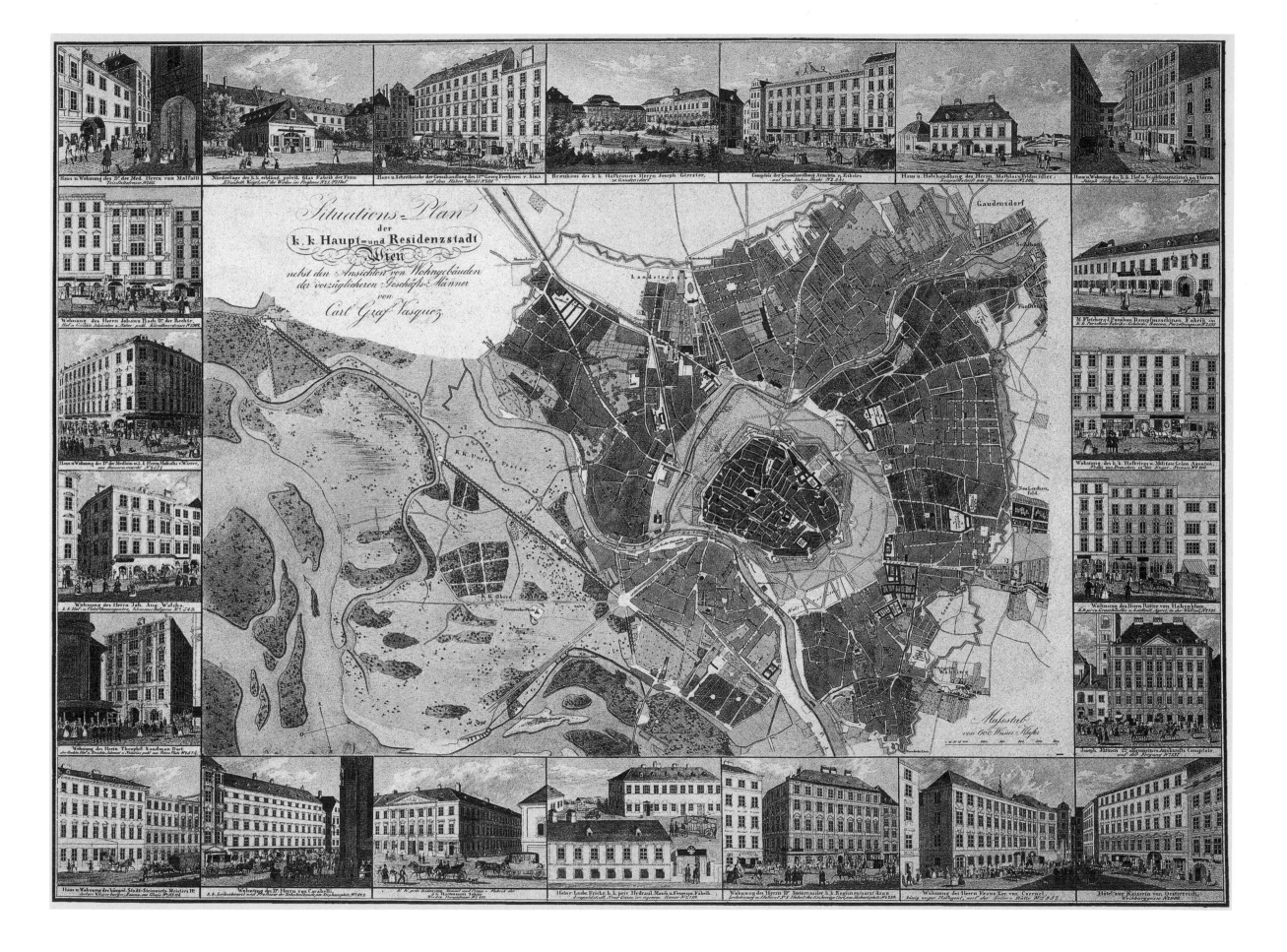

Site Map of the Imperial and Royal Capital and Residence City of Vienna with Views of Homes Owned by Better-Off Businessmen

Colored pen lithograph, published by Carl Graf Vasquez, 1827

To find one's way about Vienna in the 19th century was not an easy feat, given the many major construction projects and various changes they imposed on the cityscape. That is why, in tandem with Anton Ziegler, Count Carl Vasquez-Pinas von Löwenthal (1796–1861), a descendant of an old, but impoverished noble family, published police district maps for Vienna and the suburbs as well as a complete map of the city. All maps had the south on top, featured consecutive so-called "conscription" numbers to designate buildings and were framed by a border showing small pictures of the most striking buildings.

This map is a master plan of the city of Vienna, its border showing the residential homes of important businessmen. Ignaz Beywinkler's "home and silk factory" on Schlossgasse can be seen in the upper left; to its right is the "warehouse for the imperial-and-royal-hereditary-lands-privileged glass factory of Mrs. Elisabeth Weigel auf der Wieden im Freyhaus."

Situations-Plan der k.k. Haupt- und Residenzstadt Wien nebst den Ansichten von Wohngebäuden der vorzüglicheren Geschäfts-Männer

Kolorierte Federlithographie, herausgegeben von Carl Graf Vasquez, 1827

Eine Orientierung im Wien des 19. Jahrhunderts war aufgrund der großen Bautätigkeiten und den damit einhergehenden Veränderungen des Stadtbildes nicht einfach. Daher gab Carl Graf Vasquez-Pinas von Löwenthal (1796–1861), der einem alten, doch verarmten Adelsgeschlecht entstammte, zusammen mit Anton Ziegler Polizeibezirkspläne für Wien und die Vorstädte sowie einen Gesamtplan der Stadt heraus. Alle Pläne waren gesüdet, verzeichneten fortlaufende Konskriptionsnummern und waren umrahmt von kleinen Veduten der markantesten Gebäude.

Diese Karte ist ein Gesamtplan der Stadt Wien, eingerahmt von den Wohnhäusern wichtiger Geschäftsmänner. Oben links ist das »Haus und die Seidenzeug Fabrik« des Ignaz Beywinkler in der Schlossgasse zu finden, rechts daneben die »Niederlage k.k. erbland privil. Glas Fabrik der Frau Elisabeth Weigel auf der Wieden im Freyhaus«.

Plan de situation de l'impériale et royale capitale et résidence de Vienne avec des vues des maisons des plus excellents hommes d'affaires

Lithographie à la plume, coloriée, publiée par le comte Carl Vasquez, 1827

S'orienter à Vienne au XIXᵉ siècle n'était pas chose facile en raison des nombreux chantiers et des changements du paysage urbain qui en résultaient. C'est pour cette raison que le comte Carl Vasquez-Pinas von Löwenthal (1796–1861), qui était issu d'une ancienne famille de la noblesse appauvrie, publia avec Anton Ziegler des plans de Vienne et des banlieues comportant les districts de la police, ainsi qu'un plan complet de la ville. Tous les plans étaient orientés vers le sud, les numéros de conscription indiqués de manière continue, et encadrés de petites vedute des plus importants édifices de la ville.

Cette carte est un plan complet de la ville de Vienne, entouré des demeures d'importants hommes d'affaires. En haut à gauche, on trouve « la maison et la soierie » d'Ignaz Beywinkler dans la ruelle du château, à droite la filiale de manufacture de verre royale et impériale d'Élisabeth Weigel : « Niederlage k.k. erbland privil. Glas Fabrik der Frau Elisabeth Weigel auf der Wieden im Freyhaus ».

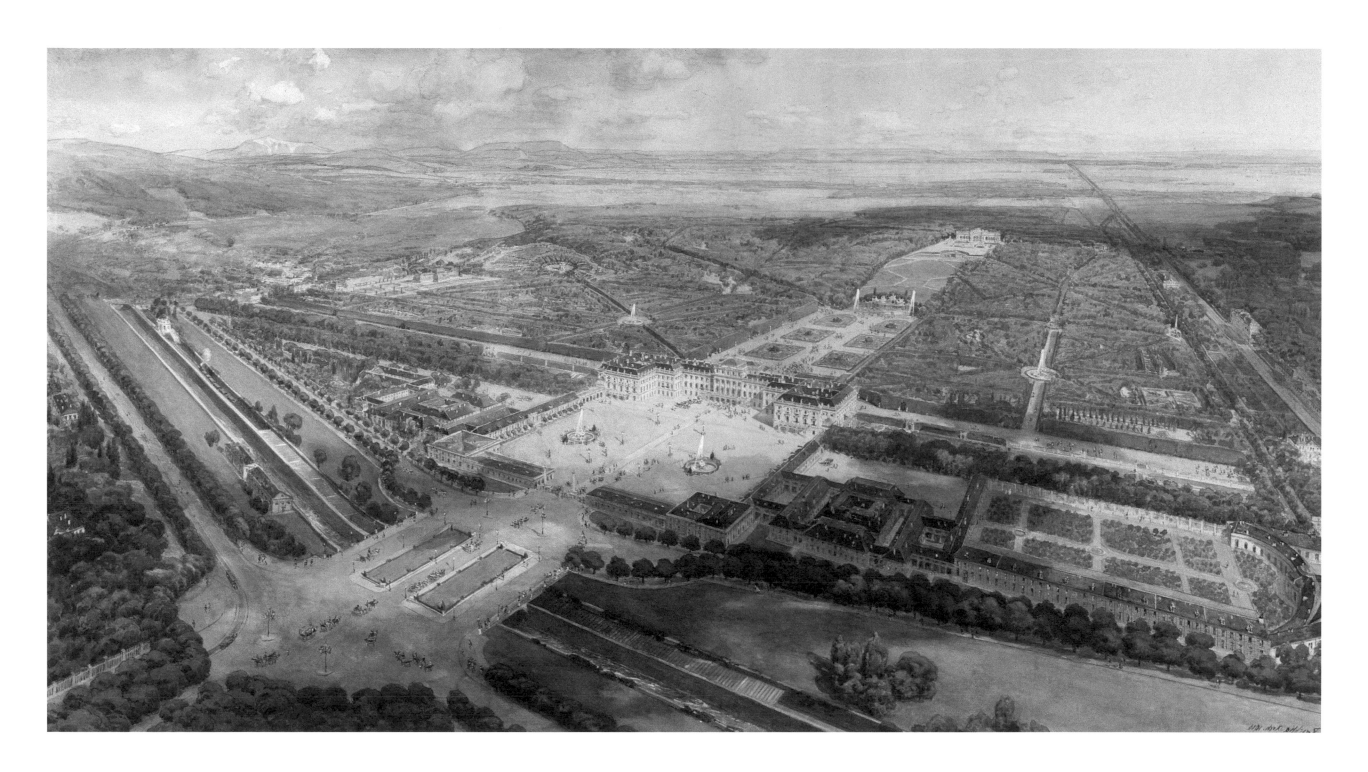

Schönbrunn Palace from a Bird's-Eye Perspective

Watercolor from the 19th century, unknown artist

As Austria's most important cultural monument, Schönbrunn Palace has been a UNESCO World Cultural Heritage Site since 1996.

Located to the west of downtown, the origins of the palace go back to the Middle Ages, when so-called "Katterburg" castle stood on this lot.

The widow of Emperor Ferdinand II (1578–1637), Eleonora von Gonzaga (1598–1655), had the house and garden lavishly remodeled and expanded in 1642 to achieve the effect of a very representational environment. After the grounds had been destroyed by the second Turkish siege in 1683, Emperor Leopold I commissioned architect Johann Bernhard Fischer von Erlach to construct a new building for Joseph I. But Schönbrunn Palace only really began to flourish when his granddaughter Maria Theresa had Nikolaus Franz Leonhard von Pacassi (1716–1790) transform it into a residential palace.

The palace contains more than 1,700 magnificent ceremonial halls, salons, guest rooms, and private quarters for the imperial family, all lavishly and expensively decorated. The impressive palace grounds feature many pools, fountains, and sculptures as well as the oldest animal menagerie in the world, (on the right-hand side of the picture, in the background). The grounds also include a Palm House with over 4,500 different plant species from all over the world, a maze, a Sun Dial House and the Gloriette, a temple with a viewing platform on the roof.

Schloss Schönbrunn aus der Vogelperspektive

Aquarell aus dem 19. Jahrhundert, unbekannter Künstler

Als wohl bedeutendstes Kulturdenkmal Österreichs wurde Schloss Schönbrunn 1996 als UNESCO-Weltkulturerbe ausgezeichnet.

Die Ursprünge des westlich der Innenstadt gelegenen Schlosses gehen bis ins Mittelalter zurück, als auf dem Grundstück noch die so genannte Katterburg stand. Die Witwe des Kaisers Ferdinand II. (1578–1637), Eleonora von Gonzaga (1598–1655), ließ im Jahr 1642 aufwendige Umbau- und Erweiterungsarbeiten am Haus sowie im Garten durchführen, um ein besonders repräsentatives Umfeld zu erhalten. Nachdem das Gelände durch die zweite Türkenbelagerung 1683 zerstört worden war, beauftragte Kaiser Leopold I. den Architekten Johann Bernhard Fischer von Erlach mit einem Neubau für Joseph I. Doch erst mit seiner Enkelin Maria Theresia und den von ihr beauftragten Umbauarbeiten durch Nikolaus Franz Leonhard von Pacassi (1716–1790) zum Residenzschloss begann die Blütezeit von Schloss Schönbrunn.

Das Schloss selbst besitzt über 1700 prächtige Zeremonieräume, Salons, Gästeräume und private Räume der kaiserlichen Familie mit aufwendiger und kostbarer Innenausstattung. Im eindrucksvollen Schlosspark befinden sich etliche Brunnen, Wasserspiele und Skulpturen sowie die älteste Menagerie der Welt, auf dem Bild rechts hinten. Weiter gehören zur Anlage ein Palmenhaus, mit mehr als 4500 unterschiedlichen Pflanzenarten aus aller Welt, ein Irrgarten, ein Sonnenuhrhaus und eine Gloriette mit Aussichtsplattform auf dem Dach.

Château de Schönbrunn à vue d'oiseau

Aquarelle du XIXᴱ siècle, artiste inconnu

En tant que monument culturel le plus important d'Autriche, le château de Schönbrunn a été inscrit en 1996 sur la liste du patrimoine mondial de l'UNESCO.

Les origines du château, situé à l'ouest du centre ville, remontent jusqu'au Moyen Âge, lorsque le château dit « Katterburg » se trouvait encore sur le site. La veuve de l'empereur Ferdinand II (1578–1637), Eléonore de Gonzague (1598–1655), fit effectuer en 1642 d'importants travaux de transformation et d'agrandissement dans le bâtiment et les jardins, afin d'obtenir un environnement particulièrement représentatif. Le site ayant été détruit lors du deuxième siège des Turcs en 1683, l'empereur Léopold Iᵉʳ chargea l'architecte Johann Bernhard Fischer von Erlach de construire un nouvel édifice pour Joseph Iᵉʳ. Ce n'est toutefois qu'avec sa petite-fille Marie-Thérèse et les travaux menés par Nikolaus Franz Leonhard von Pacassi (1716–1790) pour faire du château une résidence que commença l'apogée de Schönbrunn.

Le château lui-même possède plus de 1700 magnifiques salles de cérémonie, salons, appartements d'hôte et appartements privés de la famille impériale aux aménagements raffinés et somptueux. Dans l'impressionnant parc se trouvent nombre de fontaines, jeux d'eau et sculptures, ainsi que la plus ancienne ménagerie du monde, sur le tableau au fond à droite. De surcroît, une serre aux palmiers avec plus de 4500 espèces différentes de la flore du monde entier, un labyrinthe, une serre dite du cadran solaire et une gloriette avec une plate-forme panoramique sur le toit font partie du complexe.

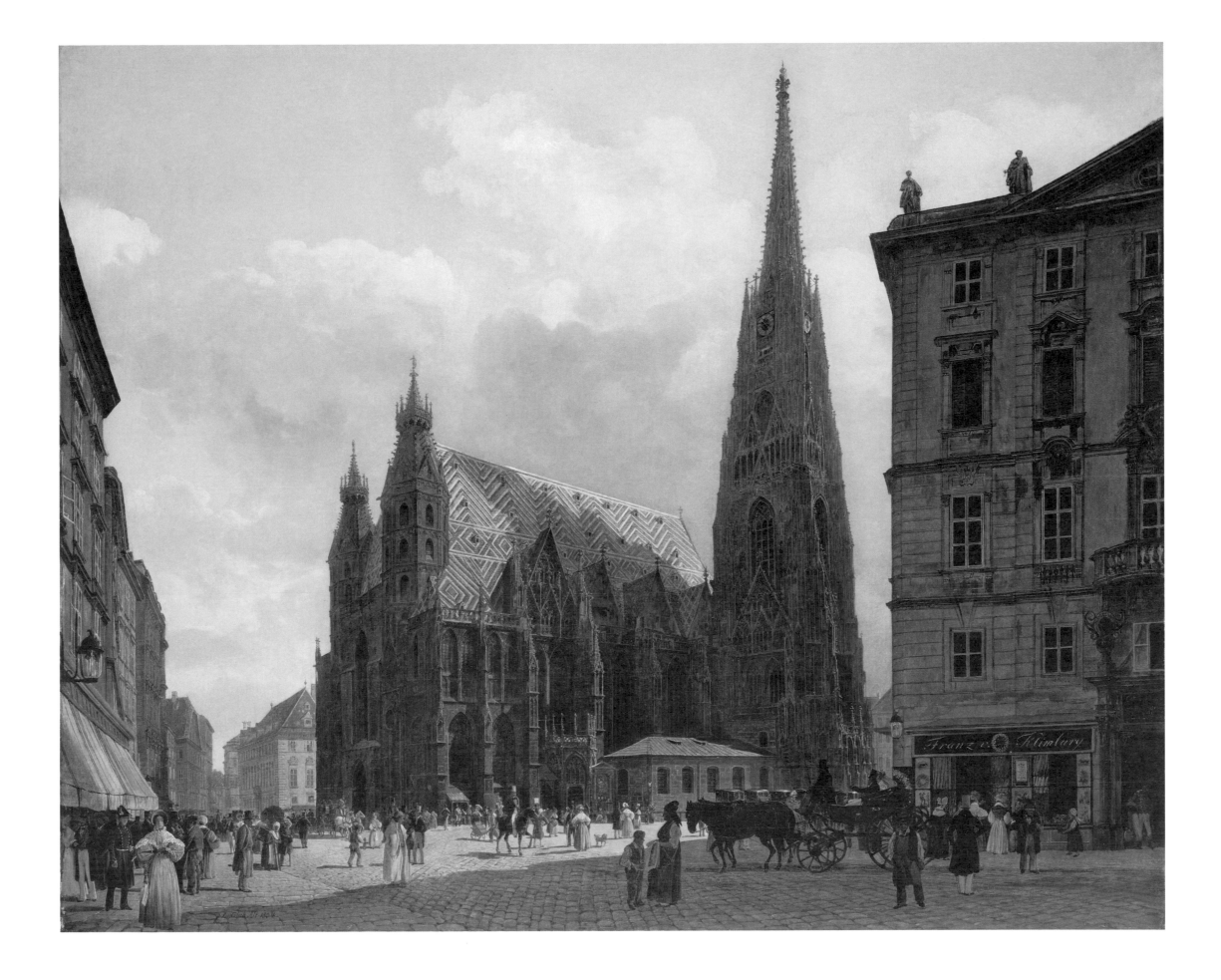

Stephansplatz Square

OIL ON CANVAS BY RUDOLF ALT, 1834

St. Stephen's Cathedral is arguably Vienna's best-known landmark and one of the most important buildings of the Central European High and Late Gothic period. Construction began in 1137; a first extension in the mid-14th century added the western facade with the Giant Gate and the so-called Heathen Towers. The cathedral began to acquire its Late Gothic appearance under Duke Rudolf IV of Habsburg (1339–1365), known as the Donor, who had the nave enlarged and the Gothic towers added. Construction of the north tower was halted in 1511 and only resumed to be completed some sixty years later; it is to this interruption that the Viennese cathedral owes its characteristically asymmetrical towers.
The south tower measures 137 meters, but the north tower tops out at 68 meters, and the west towers are 65 meters high. St. Stephen's Cathedral is 107 meters long and 34 meters wide and houses Austria's largest bell, the so-called Pummerin Bell whose name was derived from its sound. The eye-catching zig-zag pattern on the roof consists of more than 230,000 tiles.

Der Stephansplatz

ÖL AUF LEINWAND VON RUDOLF ALT, 1834

Der Stephansdom ist das wohl bekannteste Wahrzeichen Wiens und eines der bedeutendsten Bauwerke der mitteleuropäischen Hoch- und Spätgotik.
Baubeginn war im Jahr 1137, im Zuge einer ersten Erweiterung Mitte des 14. Jahrhunderts kam die Westfassade mit dem Riesentor und den so genannten Heidentürmen hinzu. Ab 1359 erhielt der Dom unter Herzog Rudolf IV. von Habsburg (1339–1365), dem Stifter, durch das vergrößerte Langhaus und die gotischen Türme sein spätgotisches Aussehen. Da die Arbeiten am Nordturm 1511 eingestellt und erst sechzig Jahre später zum Abschluss gebracht wurden, entstand die für den Wiener Dom charakteristische Asymmetrie der Türme.
Der Südturm misst 137 Meter, der Nordturm lediglich 68 Meter, und die Westtürme sind 65 Meter hoch. Insgesamt ist der Stephansdom 107 Meter lang und 34 Meter breit und beherbergt die größte Glocke Österreichs, die so genannte Pummerin, deren Name von ihrem Ton abgeleitet wurde. Das mit einem auffälligen Zickzackmuster gedeckte Dach besteht aus über 230 000 Dachziegeln.

La place Saint-Étienne

HUILE SUR TOILE DE RUDOLF ALT, 1834

La cathédrale Saint-Étienne est l'emblème le plus marquant de Vienne et l'un des plus importants édifices du gothique rayonnant et du gothique flamboyant d'Europe Centrale.
Les travaux débutèrent en 1137, puis, au cours du premier agrandissement au milieu du XIVe siècle, vinrent s'y ajouter la façade ouest avec le grand portail et les tours dites des païens. À partir de 1359, la cathédrale reçut son apparence du gothique tardif grâce à l'agrandissement de la nef principale et l'ajout des tours, sous le duc Rodolphe IV de Habsbourg (1339–1365), le fondateur. Comme les travaux sur la tour nord cessèrent en 1511 et furent achevés seulement soixante ans plus tard, c'est ainsi que l'asymétrie caractéristique pour les Viennois des tours de la cathédrale vit le jour.
La tour sud mesure 137 mètres, la tour nord seulement 68 mètres et les tours ouest font 65 mètres. La cathédrale Saint-Étienne fait au total 107 mètres de longueur et 34 mètres de largeur, elle abrite aussi la plus grande cloche d'Autriche, dite Pummerin, dont le nom vient de sa tonalité. Le toit, recouvert d'un motif en zig-zag frappant, comporte plus de 230 000 tuiles.

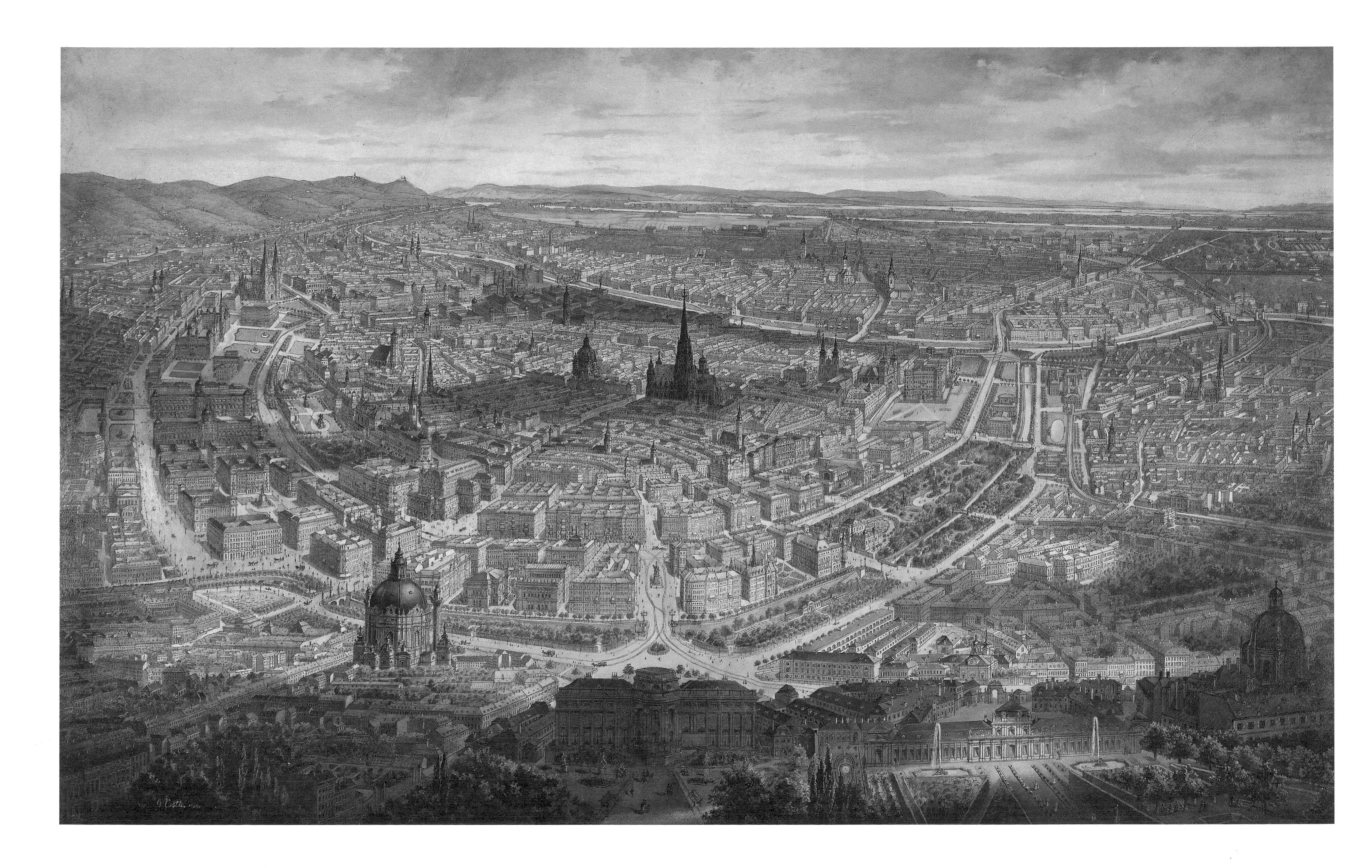

Vienna from a Bird's-Eye View

Sepia drawing by Gustav Veith, 1873

This bird's-eye view shows the Inner City, Vienna's present-day 1st municipal district.
The Lower Belvedere is visible in the foreground to the right. To its left is Schwarzenberg Palace; even further left, the Church of St. Charles rises with its towering dome and two striking columns. St. Stephen's Cathedral is located in the city's center. Rising out of Vienna's cityscape to the right of the cathedral is the Jesuit Church with its two small towers. The Jesuit Order had to build this church for the city in 1623 in return for their taking over the philosophy and theology department at the University of Vienna. To the cathedral's left is St. Peter's Church and on the same level further left, the Minorite Church, founded by Babenberg Duke Leopold VI (1176–1230) in 1224 and thus one of Vienna's oldest churches.
The view shows the Inner City after the so-called Ringstraße boulevard was built. In 1850, after Vienna's suburbs were incorporated into the city, the old city wall proved to be an annoying traffic hindrance for residents of the capital. So in December 1857, with the oft-quoted words "It is my will," Emperor Franz Joseph I ordered the razing of the city wall and the construction of a magnificent boulevard. It was the most dramatic structural redesign in Vienna's history. Built by architects Ludwig Förster (1797–1863), August Sicard von Sicardsburg (1813–1868), and Eduard van der Nüll (1812–1868), tree-lined Ringstraße is about four kilometers long and almost sixty meters wide; it was opened in May 1865.

Wien aus der Vogelschau

Sepiazeichnung von Gustav Veith, 1873

Die Vogelschau zeigt die Innere Stadt, den heutigen 1. Gemeindebezirk von Wien.
Vorne rechts im Bild ist das Untere Belvedere zu sehen. Links daneben befindet sich das Schwarzenberg Palais, noch weiter links erhebt sich die Karlskirche mit ihrer gewaltigen Kuppel und den zwei markanten Säulen. Im Zentrum der Stadt liegt der Stephansdom. Rechts des Doms ragt die Jesuitenkirche mit ihren zwei Türmchen aus dem Stadtbild Wiens hervor. Diese Kirche musste der Orden im Gegenzug zur Übernahme der Philosophischen und Theologischen Fakultät 1623 für die Stadt bauen. Links des Doms liegen die Peterskirche und auf einer Linie die Minoritenkirche, die der Babenberger Herzog Leopold VI. (1176–1230) 1224 dort gründete und die zu den ältesten Kirchen Wiens zählt.
Die Ansicht zeigt die Innere Stadt nach dem Bau der so genannten Ringstraße. Nachdem 1850 die Vorstädte Wiens eingemeindet wurden, erwies sich die alte Stadtmauer als ärgerliches Verkehrshindernis für die Bewohner der Hauptstadt. So ordnete Kaiser Franz Joseph I. im Dezember 1857 mit den oft zitierten Worten »Es ist Mein Wille« den Abbau der Stadtmauer und den Bau eines prächtigen Boulevards an. Es folgte die gravierendste bauliche Umgestaltung in der Geschichte Wiens. Die von den Architekten Ludwig Förster (1797–1863), August Sicard von Sicardsburg (1813–1868) und Eduard van der Nüll (1812–1868) erbaute und von Alleen gesäumte Ringstraße ist rund vier Kilometer lang, fast sechzig Meter breit und konnte im Mai 1865 eröffnet werden.

Vienne à vue d'oiseau

Dessin sépia de Gustav Veith, 1873

La vue d'oiseau montre le centre ville, aujourd'hui le premier arrondissement de Vienne.
À droite sur le devant du dessin, on voit le Belvédère inférieur. À côté, sur la gauche, se trouve le palais Schwarzenberg, plus loin sur la gauche s'élève l'église Saint-Charles-Borromée avec sa coupole impressionnante et les deux colonnes marquantes. Au centre de la ville est située la cathédrale Saint-Étienne. À droite de la cathédrale, l'église des Jésuites avec ses deux tourelles domine le paysage urbain de Vienne. L'Ordre dut faire construire cette église pour la ville, en contrepartie de la reprise de la Faculté de philosophie et de théologie en 1623. À gauche de la cathédrale se trouve l'église Saint-Pierre et dans son alignement, l'église des Minorites, que le duc de Babenberg, Léopold VI (1176–1230) avait fondée en 1224 et qui fait donc partie des plus anciennes églises de Vienne.
La vue montre le centre ville après l'aménagement du boulevard, dit Ringstrasse. Après l'annexion en 1850 des faubourgs de Vienne, l'ancienne enceinte de la ville se révéla être un obstacle au trafic pour les habitants de la capitale. L'empereur François-Joseph I^{er} ordonna donc en décembre 1857 par ces paroles souvent citées : « C'est ma volonté », la démolition des remparts et la construction d'un magnifique boulevard. Le plus important réaménagement de son histoire commença alors pour Vienne. Construit par les architectes Ludwig Förster (1797–1863), August Sicard von Sicardsburg (1813–1868) et Eduard van der Nüll (1812–1868), le boulevard Ringstraße bordé d'allées, fait quatre kilomètres de longueur, presque soixante de largeur et put être inauguré en mai 1865.

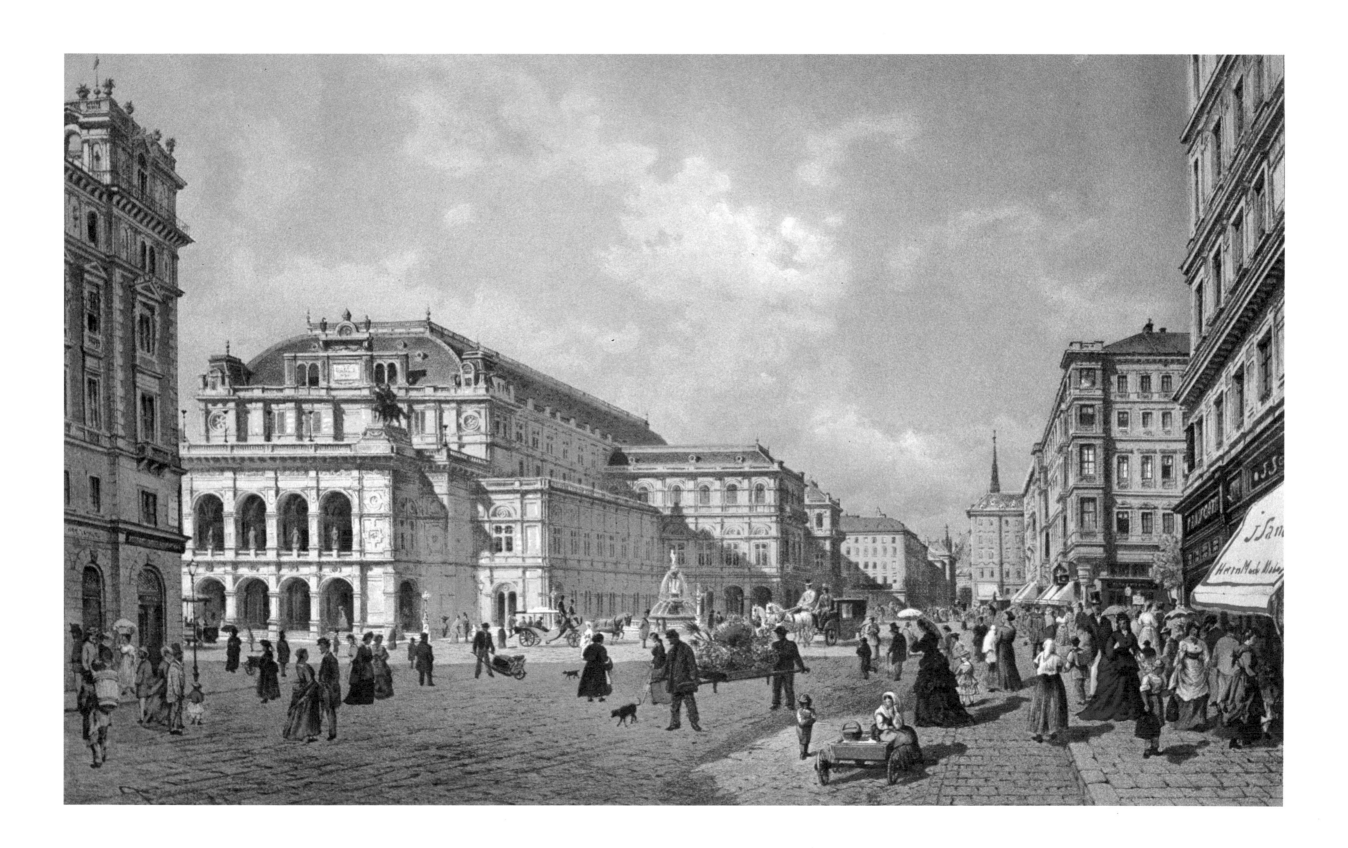

State Opera

Color etching, circa 1880,
unknown artist

Designed by architects August Sicard von Sicardsburg and Eduard van der Nüll in the Neo-Renaissance style and completed in 1869, the Vienna State Opera was one of the first magnificent buildings bordering the new Ringstraße boulevard. Initially rejected by the Viennese who thought the building had no character, it was soon transformed into a symbol of Austrian musical life as their attitudes changed. The Vienna State Opera has since become one of the most renowned opera houses in the world with musical directors such as Gustav Mahler, Richard Strauss, and Herbert von Karajan. A most significant social event is the annual Vienna Opera Ball, traditionally held on the last Thursday during carnival.

Staatsoper

kolorierte Radierung, um 1880,
unbekannter Künstler

Die Wiener Staatsoper wurde als einer der ersten Prachtbauten auf der neu angelegten Ringstraße von den Architekten August Sicard von Sicardsburg und Eduard van der Nüll im Stil der Neorenaissance errichtet und 1869 fertig gestellt. Die anfängliche Ablehnung des Gebäudes von Seiten der Wiener, die das Haus als stillos empfanden, wandelte sich bald, und das Haus wurde zum Symbol österreichischer Musikpflege. Seitdem hat sich das Wiener Opernhaus zu einer der ersten Opernadressen weltweit entwickelt, unter anderem mit den Direktoren Gustav Mahler, Richard Strauss und Herbert von Karajan. Ein gesellschaftlicher Höhepunkt ist der alljährliche Wiener Opernball traditionell am letzten Donnerstag im Fasching.

Opéra national

gravure coloriée, vers 1880,
artiste inconnu

L'opéra national de Vienne fut le premier édifice imposant à être érigé en style néo-renaissance par les architectes August Sicard von Sicardsburg et Eduard van der Nüll sur le nouveau boulevard, et achevé en 1869. Le rejet initial des Viennois, qui considéraient le bâtiment comme n'ayant aucun style, se transforma rapidement, et la maison devint le symbole de la tradition musicale en Autriche. Depuis lors, l'opéra de Vienne est devenu l'une des premières adresses d'opéra du monde, entre autres sous la direction de Gustav Mahler, Richard Strauss et Herbert von Karajan. L'un des temps forts de la vie de la haute société est le bal annuel de l'opéra qui a lieu tradtionnellement le dernier jeudi du Carnaval.

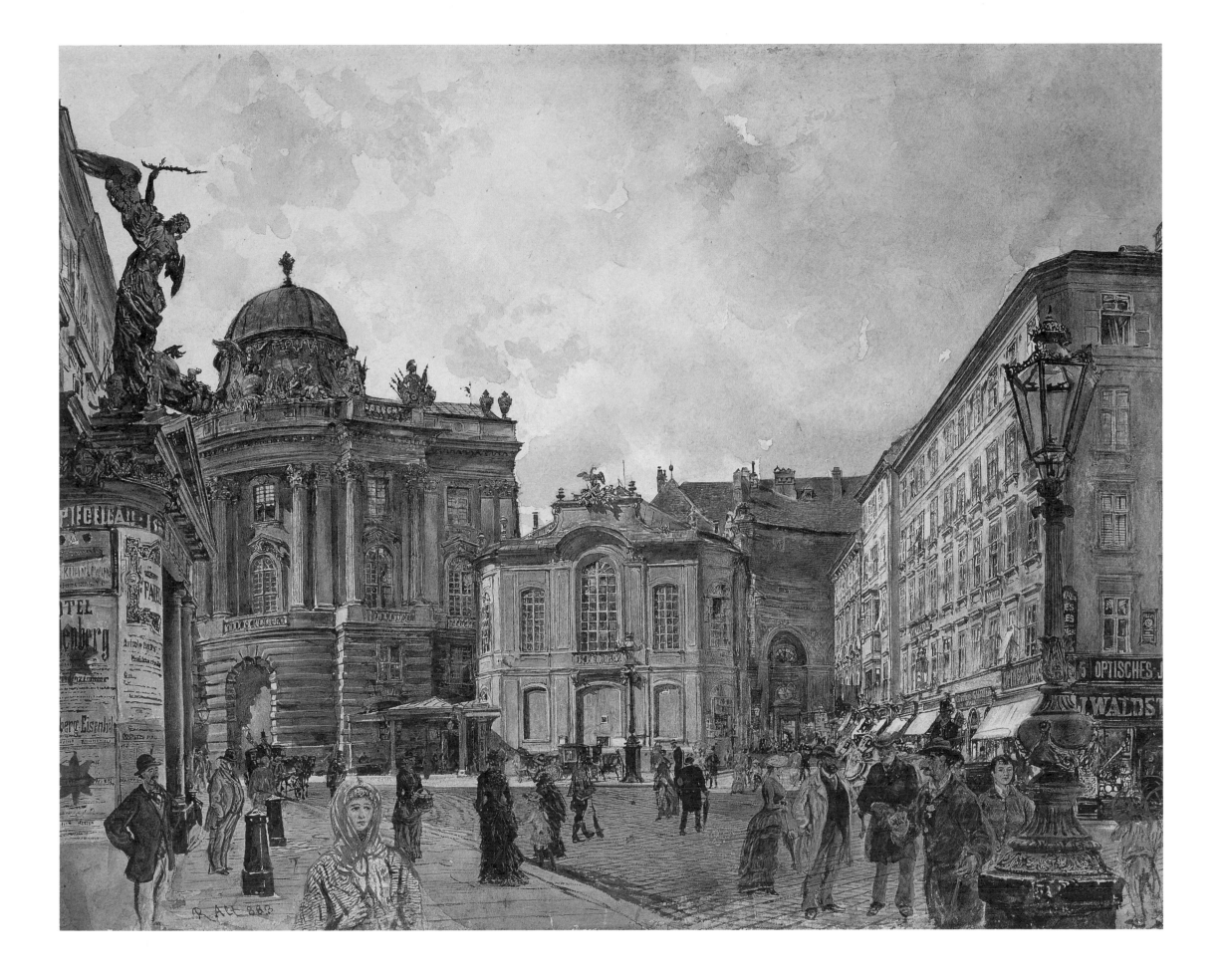

Michael Square

Watercolor by Rudolf Ritter von Alt, 1883

Today, Michael Square connects the old Hofburg Castle with the pedestrian zone around Stephansplatz Square in central Vienna.
In the center of this picture, the old Vienna Burgtheater still stands; it was torn down in 1888 to make way for the construction of the Michael Wing of Hofburg Castle.
But only a few days after the old building was closed, the new Burgtheater on Dr.-Karl-Lueger-Ring was inaugurated. Today, it is one of the most important stages in the world. The new building was designed by Gottfried Semper and Karl Freiherr von Hasenauer; its ceiling frescoes are joint works by Gustav and Ernst Klimt as well as Franz Matsch.
The large building to the left houses the Winter Riding School; today, it adjoins the Michael Wing and connects to the "Stallburg" (stables) across the square. The fifty-meter-long, almost twenty-meter-wide Riding Hall, adorned with forty-two Corinthian columns and regarded as the most beautiful one in the world, is used by the Royal Spanish Riding School for exercise and performances.
In 1927, Vienna's first traffic circle was installed at Michael Square.

Der Michaelerplatz

Aquarell von Rudolf Ritter von Alt, 1883

Im Zentrum Wiens verbindet der Michaelerplatz heute die alte Hofburg mit der Fußgängerzone um den Stephansplatz.
In der Mitte des Bildes steht das alte Wiener Burgtheater, das 1888 dem Bau des Michaelertrakts der Hofburg weichen musste. Doch bereits einige Tage nach der Schließung des alten Gebäudes, wurde das neue Burgtheater am Dr.-Karl-Lueger-Ring eingeweiht. Es zählt heute zu den bedeutendsten Bühnen der Welt. Entworfen wurde das neue Haus von Gottfried Semper und Karl Freiherr von Hasenauer, seine Deckengemälden sind Gemeinschaftsarbeiten von Gustav und Ernst Klimt sowie Franz Matsch.
In dem großen Gebäude links befindet sich die Winterreitschule, die heute an den Michaelertrakt anschließt und mit der gegenüberliegenden Stallburg verbunden ist. In dem fünfzig Meter langen und fast zwanzig Meter breiten Reitsaal, der mit sechsundvierzig korinthischen Säulen geschmückt ist und als der schönste der Welt gilt, finden die Übungen und Vorführungen der Spanischen Reitschule statt.
1927 wurde am Michaelerplatz der erste Kreisverkehr Wiens eingerichtet.

La place Michaeler

Aquarelle de Rudolf Ritter von Alt, 1883

Au centre de Vienne, la place Michaeler relie aujourd'hui le vieux château du Hofburg avec la zone piétonnière de la place Saint-Étienne.
Au milieu du tableau se tient encore l'ancien théâtre Burgtheater, qui dut laisser la place en 1888 à l'aile Michaeler du Hofburg. Toutefois, déjà quelques jours après la fermeture de l'ancien bâtiment, le nouveau théâtre fut inauguré sur le boulevard Dr.-Karl-Lueger-Ring. Il fait aujourd'hui partie des plus importantes scènes du monde. La nouvelle maison fut conçue par Gottfried Semper et Karl Freiherr von Hasenauer, les peintures de ses plafonds sont le fruit d'une collaboration entre Gustav et Ernst Klimt, ainsi que Franz Matsch.
Dans le grand bâtiment à gauche se trouve l'école d'équitation d'hiver, abouchée aujourd'hui à l'aile Michaeler et reliée avec le « Stallburg » (écuries) situé en face. Dans le manège, long de cinquante mètres et large de presque vingt mètres, décoré de quarante-six colonnes d'ordre corinthien et qui passe pour le plus beau du monde, ont lieu les entraînements et présentations de l'École d'équitation espagnole.
En 1927, le premier rond-point de Vienne fut érigé sur la Michaelerplatz.

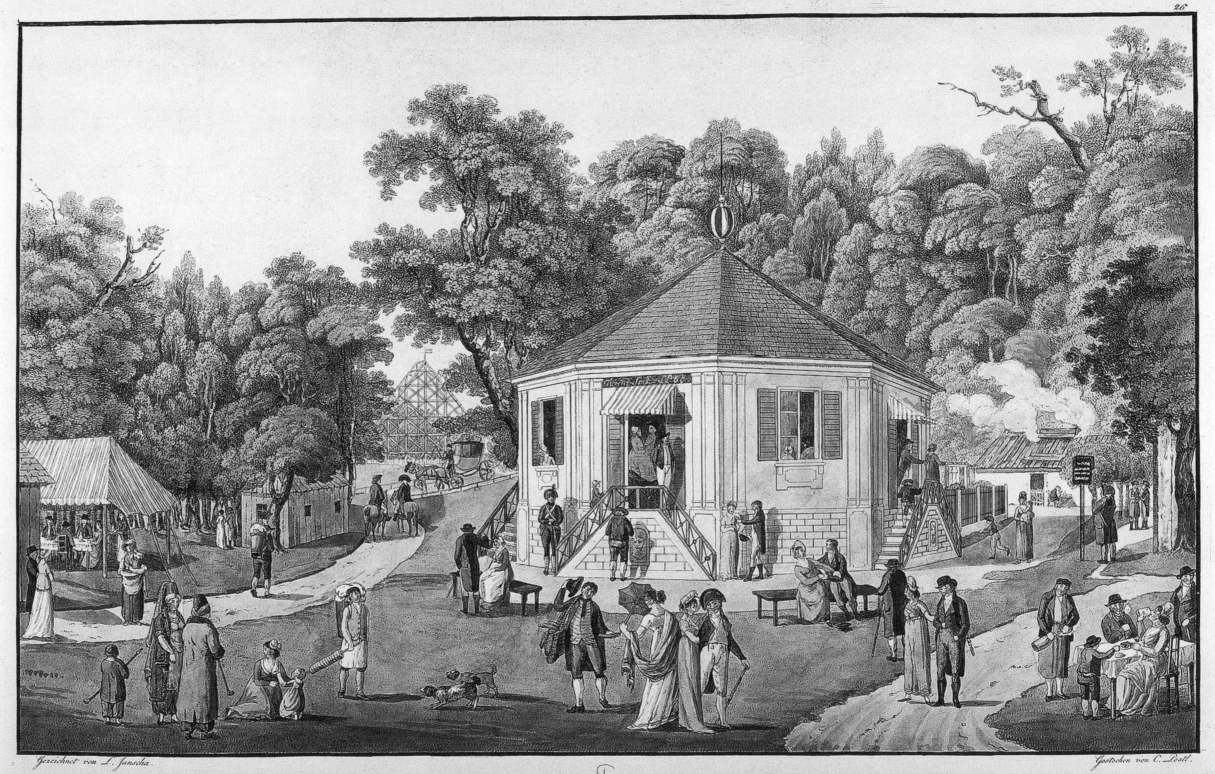

Gezeichnet von L. Janscha.

Gestochen von C. Postl.

DAS NEUE WIENER RINGELSPIEL IM PRATER. VUE DU JEU DE BAGUE, OU CAROUSSEL, AU PRATER.

Wien bey Artaria Comp.

The New Vienna Merry-Go-Round in the Prater

OLD COLORED ENGRAVING BY C. POSTL AFTER LAURENZ JANSCHA, FROM: *PICTURESQUE AND REMARKABLE VIEWS OF THE VARIOUS PROVINCES OF THE AUSTRIAN MONARCHY, AROUND 1810*

The "Wurstelprater" or amusement park in the Prater was and in fact remains the most popular day-trip destination for the Viennese: here entertainment includes puppet booths, merry-go-rounds, and large and small swings; magicians, fire-eaters, clowns and acrobats, giants and dwarves offer their art as do showpeople with flea circuses and monkey theaters; exhibits showcasing animals, foreign cities and wax figures amaze the visitors; they can amuse themselves in the hall of mirrors, take a train ride through a haunted house, and enjoy rollercoaster rides; salami vendors and many restaurants and Prater food stalls provide refreshments. Visitors looking for peace and tranquility will find it under the many shady trees dotting the lush meadow landscape.

Das neue Wiener Ringelspiel im Prater

ALTKOLORIERTER STICH VON C. POSTL NACH LAURENZ JANSCHA, AUS: *MALERISCHE UND MERKWÜRDIGE ANSICHTEN DER VERSCHIEDENEN PROVINZEN DER ÖSTERREICHISCHEN MONARCHIE, UM 1810*

Das Lieblingsausflugsziel der Wiener war und bleibt wohl der Wurstelprater, der Vergnügungspark des Praters: Hier unterhalten Marionettenbuden, Ringelspiele (Karussell) und Schaukeln Groß und Klein; Taschenspieler, Feuerschlucker, Clowns und Akrobaten, Riesen und Zwerge bieten ihre Kunst dar genauso wie Schausteller mit ihrem Flohzirkus und Affentheater; Ausstellungen von Tieren, fremden Städten und Wachsfiguren erstaunen die Besucher; in Spiegelkabinetten, Geisterbahnen und Achterbahnen kann man sich zerstreuen; Salamiverkäufer sowie zahlreiche Gasthäuser und Praterhütten sorgen für das leibliche Wohl. Wer Ruhe sucht, findet sie unter den zahlreichen schattenspendenden Bäumen der üppigen Auenlandschaft.

Vue du jeu de bague, ou Caroussel viennois, au Prater

GRAVURE, COLORIS D'ÉPOQUE, DE C. POSTL D'APRÈS LAURENZ JANSCHA, TIRÉE DE : *VUES PITTORESQUES ET ÉTRANGES DE DIFFÉRENTES PROVINCES DE LA MONARCHIE AUTRICHIENNE, VERS 1810*

Le but d'excursion préféré des Viennois était et reste le « Wurstelprater », le parc d'attractions du Prater : ici, des théâtres de marionnettes, des carrousels et des balançoires font la joie des grands et des petits ; prestidigitateurs, cracheurs de feu, clowns et acrobates, géants et nains présentent leur art, tout comme les forains avec leurs cirques de puces et leurs théâtres de singes ; exposition d'animaux, de villes étrangères et de figures de cire suscitent l'étonnement des visiteurs ; on peut se distraire avec des miroirs déformants, des trains fantômes et le grand huit ; des vendeurs de salami ainsi que d'innombrables auberges et guinguettes se chargent de combler les papilles. Celui qui cherche le calme le trouvera sous les nombreux arbres qui ombragent le foisonnant paysage riverain du fleuve.

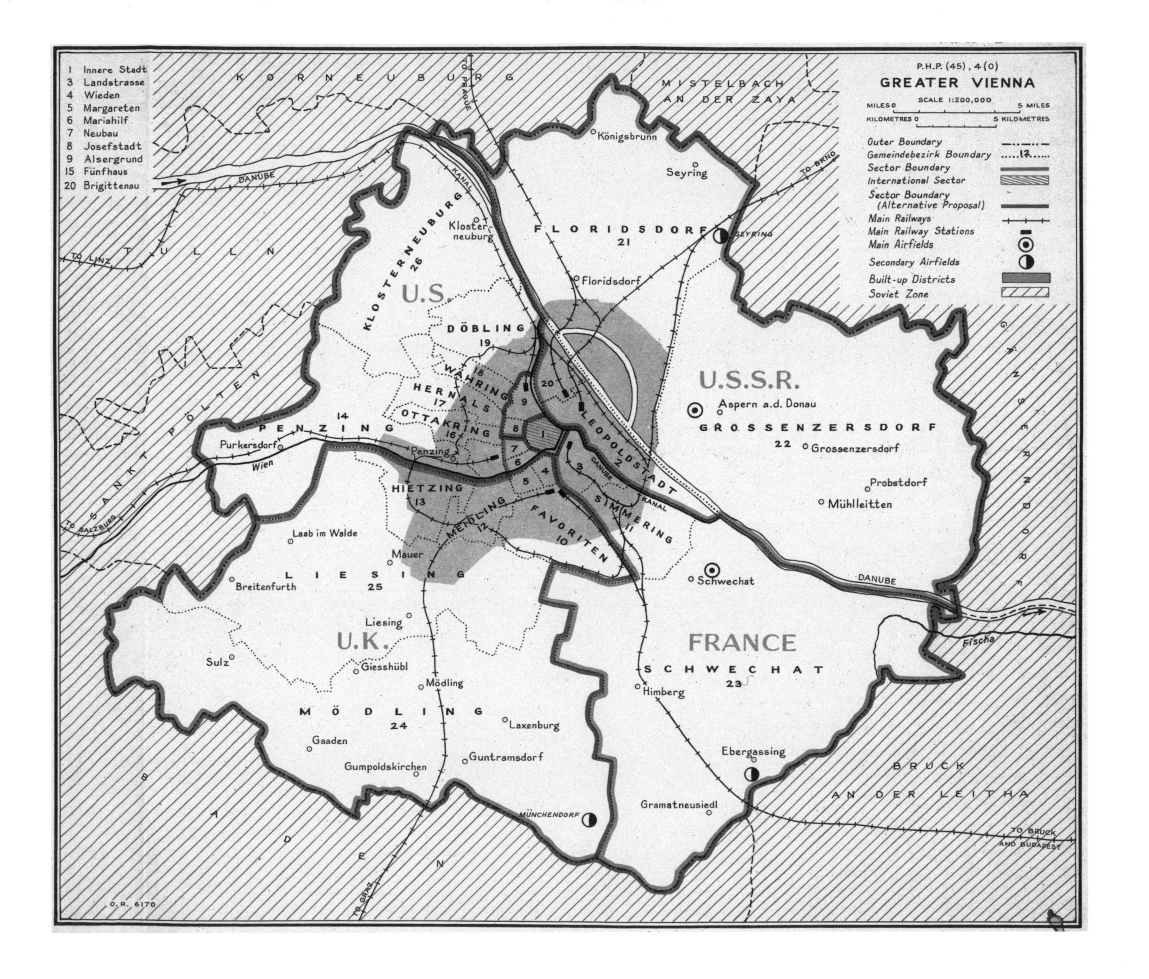

Map with zones of Vienna's Allied occupation, 1945

Like the German capital of Berlin, in 1945 after the end of the Second World War, Vienna, too, was divided into four sectors except for the Inner City that was declared an Inter-Allied zone. However, the division imposed by the four victorious powers only applied to the area of Vienna within the borders of 1937, that is, before the National Socialists hatched their design to build a Great Vienna.

The city looked just like other major cities after the end of World War II: Vienna lay in ruins; canals, gas and water pipes had suffered severe damage, and twenty percent of the buildings were destroyed.

Carol Reed's film "The Third Man" with Orson Welles was set in the Vienna of this time when the black market blossomed and gangs were up to no good.

Karte mit den alliierten Besatzungszonen von Wien, 1945

Wie die deutsche Hauptstadt Berlin, so wurde auch Wien 1945 nach dem Ende des Zweiten Weltkriegs in vier Sektoren aufgeteilt, mit Ausnahme der Inneren Stadt, die zur Interalliierten Zone erklärt wurde. Die Aufteilung der vier Siegermächte bezog sich allerdings nur auf das Gebiet Wiens in den Grenzen von 1937, das heißt vor den nationalsozialistischen Plänen zur Bildung eines Groß-Wien.

Die Stadt bot das gleiche Bild wie andere Großstädte nach Beendigung des Krieges: Wien lag in Trümmern, Kanäle, Gas- und Wasserleitungen hatten schwere Schäden erlitten, und zwanzig Prozent der Häuser waren zerstört.

Carol Reeds Film »Der dritte Mann« mit Orson Welles spielt im Wien dieser Zeit, als der Schwarzhandel blühte und Banden ihr Unwesen trieben.

Carte avec les zones d'occupation de Vienne des Alliés, 1945

Comme la capitale allemande Berlin, Vienne a également été divisée en quatre secteurs en 1945 après la fin de la Seconde Guerre mondiale, à l'exception du centre ville, qui fut déclaré zone interalliée. La répartition des quatre vainqueurs ne se rapportait toutefois qu'à la zone de Vienne dans les limites de 1937, ce qui signifie avant les plans nationaux-socialistes d'une Grande Vienne.

La ville offrait la même image que d'autres grandes villes à la fin de la guerre : Vienne gisait sous les décombres ; les égouts, les canalisations de gaz et d'eau avaient subi de graves dommages et vingt pour cent des immeubles étaient détruits.

Le film de Carol Reed, « Le troisième homme » avec Orson Welles, se déroule dans la Vienne de cette époque, lorsque le marché noir fleurissait et que des bandes faisaient régner leur loi.